A GUIDE TO
COLLECTING
STUDIO POTTERY

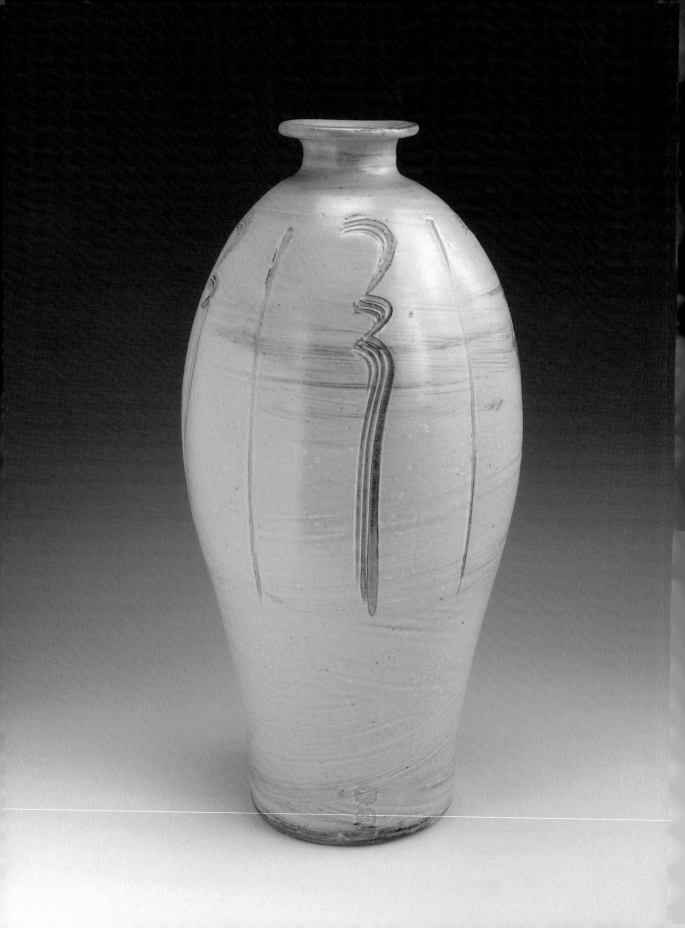

A GUIDE TO
COLLECTING
STUDIO POTTERY

Alistair Hawtin

A & C BLACK
LONDON

ACKNOWLEDGEMENTS

Thanks are due to David Binch, Phil Rogers, Tony Hill, Gail Finch, Steve Uchytil, John Maltby, Stephen Sell, Hal Higginbottom, Martin Browne, Ben Williams, Robert Fournier, John Clark, Adrian Sassoon, Kate Malone, and Edmund de Waal, John Shakeshaft, Galerie Besson and the Barrett Marsden Gallery.

First published in Great Britain in 2008
A & C Black Publishers Limited
38 Soho Square
London W1D 3HB
www.acblack.com

ISBN 13: 978-07136-7189-6

Book design by Jo Tapper
Cover design by James Watson
Cover images: (Front) (Main image), Vessel by Bodil Manz. *Photo courtesy of Galerie Besson.* (Top, left to right), Vessel by Lucie Rie, *Tiger with Rider* by John Maltby, teabowl by Edmund de Waal, small bottle by Janet Leach, plate by Derek Emms.
(Back, top to bottom): Cat by Emma Rodgers, stoneware cup by John Maltby, stoneware chawan by Shoji Hamada, *Gourd Form* by Kate Malone, chawan by Ewen Henderson.

Printed and bound in China.

This book is produced using paper that is made from wood grown in managed, sustainable forests. It is natural, renewable and recyclable. The logging and manufacturing processes conform to the environmental regulations of the country of origin.

Frontispiece: Stoneware bottle by Jim Malone, ht: 40 cm (15¾ in). Incised decoration through white slip under a clear glaze. *Photo by David Binch, by kind permission of the artist, private collection.*

DEDICATION

This book is dedicated to the memory of two very special men; my father
Frank Hawtin and William (Bill) Marshall.

Boat form by Bryan Newman.
*Photo by David Binch, private
collection.*

Contents

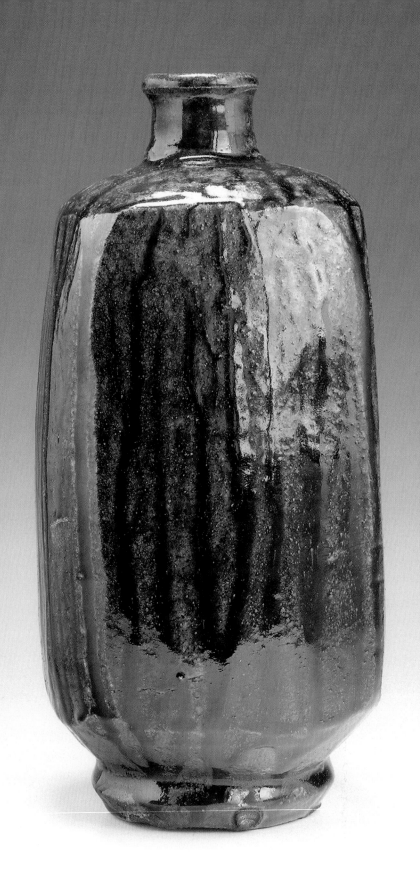

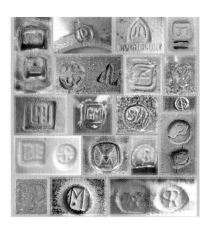

Introduction

I have written this book as a self-confessed 'potaholic', that is, someone who is obsessed by pots! It is my opinion that people who are 'serious collectors' of anything really need to take a close look at themselves, as obsession can indeed prove to be somewhat unhealthy.

Take my own case, for instance. Why does a seemingly normal person who has a good job and does all the things that normal people do – hold dinner parties, visit the pub, and go on holiday to Spain – suddenly develop an obsession? Why does this obsession take over his life to the extent that there is 'always room for just one more pot in the house'? If you have identified with this description, it is probably too late to save you; if not, you may wish to take heed and retreat now, before you become hooked!

Despite the relatively low profile of studio pottery as a subject for collection, there are and have been several high-profile collectors. Charles Laughton the film actor had a superb collection, as does Herbert Lom. David Attenborough, the naturalist, filmmaker and television presenter, has a very impressive collection, as did sculptor Eduardo Paolozzi, while others known to collect include musicians Eric Clapton and Mitsuko Uchida, fashion designers Zandra Rhodes, Donna Karan, Issey Miyake and Shirin Guild, and the celebrated BBC reporter Kate Adie. Famously, Sir Robert Sainsbury and his wife Lisa gathered together the most stunning collection of the work of Lucie Rie and Hans Coper, most of which is housed at the University of East Anglia in Norwich, England.

This book is called *A Guide to Collecting Studio Pottery*, but when related to an obsession for pots, what is it *really* about and *how* does this manifest itself?

Above: Potters' marks, including those of the following; Jim Malone, David Leach, John Leach, John Mathieson, Janet Leach, Mandy Parslow, Ray Finch, Warren MacKenzie (early mark), Gareth Mason, Sarah Walton, Ian Gregory, Bernard Leach & Leach Pottery, Mick Casson, Stephen Parry, Michael Cardew & Winchcombe, Mike Dodd, John Maltby, Phil Rogers. *Photo by David Binch.*

Opposite: Bottle by Shoji Hamada, ht: 30 cm (11¾ in). Cut-sided with runny ash glaze. Note the unevenness of the cut sides. *Photo by David Binch, by permission of Tomoo Hamada, private collection.*

Contemporary ceramics by
Lisa Hammond. Lisa soda-
fires at her studio in Maze
Hill, Greenwich, London.
*Photo by Alistair Hawtin, by
kind permission of the artist..*

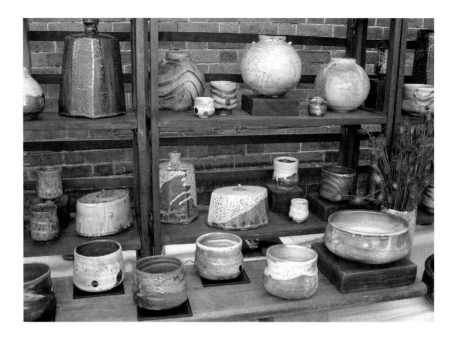

Let us first define the subject. My book is predominantly about collecting
ceramics made, for the most part, by men or women working on their own,
or with maybe one or two assistants in a small workshop. It is not about
collecting factory-made items or anything produced on a large scale. It is
written for collectors, by a collector, in the hope that some of the writer's
passion for pots can inspire others to start a collection or to develop the one
they already have with more clarity and purpose.

There is also the hope that my book will be of use to the antiques trade to
fill a void I believe presently exists. As far as I know, no current book covers
the subject from the viewpoint of the collector. As a result, dealers frequently
attempt to sell poor pots at vastly inflated prices; equally, much to the
collectors' pleasure, good pots can occasionally sell very cheaply.

At this point I have to emphasise that this book, although trying to cover
a broad spectrum of most aspects of studio pottery, will quite naturally
reflect something of my own taste in pots. I am an obsessive collector and
collect a certain genre of pot passionately and discriminately. I make no
apologies for this.

Within some of the chapters, I have included an interview with a
collector. Through including the views of others, which may contrast with
my own, I hope to broaden the concept of what collecting is or can be. Taken
together, these differing opinions should provide the reader with insight into
what interests collectors and drives them to develop their collections.

I have also tried to ensure that the book has an international feel to it,
though British potters inevitably receive a greater focus than do their
international counterparts. Of course, this is partly because I live in Britain,
but also because many of the most collectable potters happen to be British.

Opposite: Porcelain bud vase
by Bernard Leach, ht: 10 cm
(4 in). Green celadon glaze
and an incised decoration.
Note how the decoration
perfectly complements the
form of the pot. *Photo by
David Binch, by kind permission
of John Leach, private collection.*

A Brief History of the Development of Studio Pottery

Functional ware for everyday use has been made in pottery workshops all over the world for millennia. It would be quite unfair to deny artistic merit or talent to these artisans. However, artisan potters were governed purely by the need to make a living, and their chosen means was to make pots. They produced beautiful functional items, often with some artistic flair, and as such have provided inspiration for those that have followed them, but their primary motivation was not aesthetic.

Although there were pots made in studios by individual potters before Bernard Leach opened the Leach Pottery in St Ives, they could not truly be identified as an aesthetic movement; just individuals making pots, often in a pioneering situation, with little or no connection to other potters or to any technical assistance. If there was one group of people who deserve to be singled out from others it was the French potters of the late 19th and early 20th centuries, who made some important if, in my opinion, aesthetically rather uninteresting pots. These included Emile Decoeur, Félix Auguste Delaherche, Ernest Chaplet and Émile Lenoble.

On this side of the Channel, during the same period, other potters were also taking steps to move away from industrialized, mass-produced ceramics. The Martin Brothers (eldest brother Wallace and his three younger siblings, Walter, Charles and Edwin) worked in Fulham and later in Havelock Road, Southall, London in the 1870s. However, although they had begun to make the move from factory to studio, their pottery retained a strong Victorian

Above: Detail from a plate by Derek Emms (see p.17).

Opposite: Ash-glazed slab bottle by Bernard Leach, ht: 19 cm (7½ in). Note how the glaze pools where it is restricted in its movement by either a flatter area or by the incisions. *Photo by Phil Rogers, by kind permission of the artist, private collection.*

aesthetic, and thus they did not contribute significantly to the growth of an independent movement.

There were also major contributions in other parts of the world, particularly in Japan, led by Kawai, Tomimoto and, (on his return from working with Bernard Leach at St Ives), Hamada, initially in a fairly localized way. Later, potters in the USA, Germany and Australia developed their own relatively idiosyncratic movements. However, the concerted development of the studio pottery movement in Britain has persuaded me to concentrate largely on the work of potters from these islands, principal among whom was arguably the most influential potter of the 20th century, Bernard Leach. Leach's impact on a small but very willing and enthusiastic group of like-minded people created the impetus for a new aesthetic movement in the development of ceramics.

Bernard Leach was born in the Far East in 1887. His mother died in childbirth, and having spent his early childhood years in Japan and Hong Kong, he returned to his father's native England at the age of ten. In 1909, having finished his education in England, he travelled back to Japan with the intention of teaching the Japanese the technique of etching. In 1911, on what was ultimately to prove a very significant occasion, Leach was taken to a gathering of artists and poets who were making pots by the raku process. He was presented with a rough, low-fired bowl to decorate. After tentatively painting a design on the surface, it was taken away from him and fired in a small charcoal-fired kiln, then returned to him a short time later, still hot. Leach was so completely entranced by the immediacy of the process that he became overwhelmed by the desire to make pots. On returning to England in 1920 with his friend and fellow potter Shoji Hamada, and with the assistance of a rich benefactor, he was able to set up a pottery at St Ives.

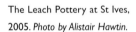

The Leach Pottery at St Ives, 2005. *Photo by Alistair Hawtin.*

The Leach Pottery, almost from the beginning, had a policy of taking in students, most of whom would have paid for the privilege. Significant amongst these were Michael Cardew, Katharine Pleydell-Bouverie and Norah Braden. Cardew joined the pottery in 1923 and Pleydell-Bouverie in 1924. Leach later introduced an apprentice system that provided the workforce to maintain the pottery's standard range, allowing Leach to make his individual pieces. The first apprentice, taken on in 1938 at the age of 14, was William (Bill) Marshall. During one of my visits to Bill, I asked him how he came to be an apprentice at the pottery, and he said, 'Well, Mr Leach [in fact, Bernard's son David] visited the school and came into my classroom. He asked, "Is there a boy here who'd like to come and work at the pottery?" and I found I had my hand up!'

Through Leach's enthusiasm for a pottery 'community' in the style of those country potteries championed by William Morris, and his almost evangelical spreading of the 'pottery gospel', many other potteries were established. Potters such as Michael Cardew (who left to set up Winchcombe Pottery) served their time with Leach and then, using the skills acquired, moved on. The British studio pottery movement had begun.

While in Japan, Leach had participated in an intellectual debate, particularly with his friends Soetsu Yanagi and Kenkichi Tomimoto, regarding the state of art and design at the time. As a group, they became convinced that the arts were afflicted by a separation of the intellectual, spiritual and practical aspects of life. Leach felt that it was only by combining the head,

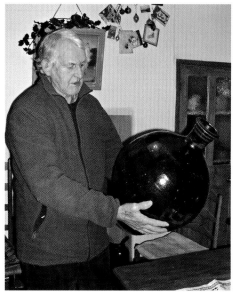

Bill Marshall holding one of his large bottles with tenmoku glaze, made in the 1960s. *Photo by David Binch, by kind permission of Marjorie Marshall, private collection.*

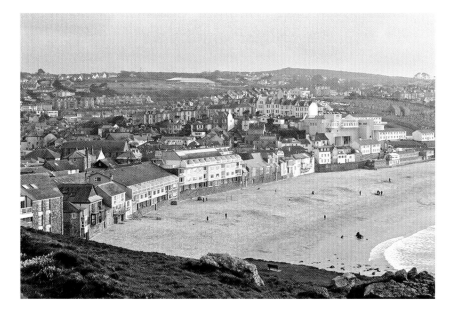

View of St Ives. *Photo by David Binch.*

heart and hand, and by selfless humility, that one could achieve greater understanding. The notion of objects speaking directly to the soul was conceived; true beauty was seen in simple, anonymous objects made for everyday use. Leach set out to follow this path by creating repetition or standard wares for the use of everyone, not just the elite. The philosophical idea behind the group established by Yanagi, Kawai, Hamada and others was known as Mingei, an invented Japanese word meaning 'folk-craft', and its influence is still felt today. Yanagi's thoughts are encapsulated in his wonderfully enjoyable book, *The Unknown Craftsman*. A pot made in this spirit will often communicate something spiritual, even moral, to those who can understand the message. The description that a pot 'sings' applies to the best of these!

Although Bernard Leach was probably the most significant individual at this time, he was by no means the only maker of individual pots. At the same time that Leach was working in both St Ives and London, William Staite Murray was also at work in Rotherhithe, London. Although sharing similar religious beliefs at the time – Leach and Staite Murray both leant towards Buddhism – Staite Murray, who was Head of Pottery at the Royal College of Art, believed that pottery was the link between painting and sculpture, and should be treated with the same high regard as other fine art. He often exhibited his pots in London galleries at what were for the time very high prices. This was in contrast with Leach, who, although also exhibiting in London, was selling for lower prices, as he never felt that his pots were 'Art', and was also keen that they were affordable to the masses. Staite Murray's influence was ultimately to prove less significant than that of Leach, although through his teaching at the Royal College he certainly secured a following as faithful. His ardent disciples included Sam Haile, Robert Washington, Margaret Rey, Heber Matthews, and latterly Henry Hammond and Helen Pincombe.

Bowl by William Staite Murray, dia: 17 cm (6¾ in). *Photo by Alistair Hawtin, by kind permission of the artist's estate, private collection.*

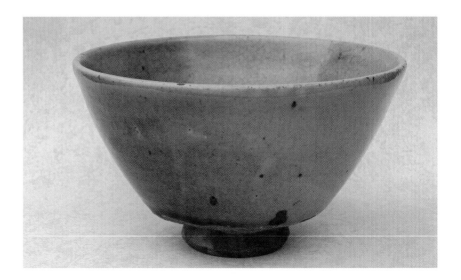

Staite Murray visited Rhodesia just as war broke out and remained there, apparently without making a single pot, until 1957, when he came back to England to oversee an exhibition of the pots he had left behind. This was commercially unsuccessful, and most of the pots were given away to his family. He returned to Africa, where he died in 1962.

One other potter from this era who was highly regarded but ultimately did not have a great impact on the development of contemporary ceramics was Charles Vyse. Vyse had been a designer in Stoke and produced his best work in Chelsea in the 1930s. He was a recognized sculptor and is known for his important experimentation with high-fired Chinese-style stoneware. Unfortunately, though his pots are technically excellent, in my opinion they rarely have soul, appearing rather to be a stiff, if accurate, imitation of the pots he most admired. A better interpreter was Derek Emms, an example of whose work is illustrated below.

Plate by Derek Emms (with a modern Chinese example shown lying flat), dia: 20 cm (7¾ in). Chun glaze. *Photo by David Binch, by kind permission of the artist's estate, private collection.*

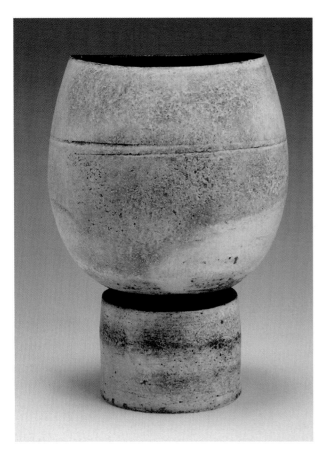

Cup form by Hans Coper,
ht: 18 cm (7 in). Stoneware.
The timeless forms Hans
Coper used make his work
very popular today. *Photo by
David Binch, by kind permission
of the artist's estate, private
collection.*

Bernard Leach continued to run the
Leach Pottery during the Second World War,
largely through orders he received from both
Heal's and Liberty, though in the same
period he also attracted a certain amount
of suspicion from locals on account of his
Japanese connections. It was a hard time for
most potters (as it was for everyone else, of
course), and a genuine revival in fortune
came only with the restoration of peace.

Although the period just before the war
had been a relatively quiet period in the
studio pottery movement, the late 1930s
saw two vitally important potters arrive in
England from war-threatened Europe: Lucie
Rie from Austria and Hans Coper from
Germany. Rie set up a workshop in her
mews house near Hyde Park in London,
where she remained until her death in 1995.
Her pots were most unlike those made and
promoted by Bernard Leach, but the two
potters held each other in mutual admiration
and respect, and were great friends.

Hans Coper met Lucie Rie in 1946, and
they soon became friends and working
partners. Coper helped Rie produce sets of
tableware, and some pieces carry their joint monogram seals. One of my
most precious pieces – though it is not of great monetary value – is a plate
which is black on top and white underneath, bearing both seals. The thought
that both these wonderful potters had a hand in its production makes it very
special. Robin Tanner, the well-known educator and etcher, used to say that
once you drank tea out of Lucie Rie's porcelain you could never go back to
anything else!

After the war, particularly during the 1950s, Leach had great success
with both standard (repetition) ware and, because of an increased
demand, his more individual pieces. He also travelled a great deal and
became much lauded for his lectures in both North America and Japan.
Through the apprentice system and the policy of taking on students,
the influence of Leach began to spread across the world. Having been
apprenticed at the Leach pottery from 1957 to 1958, Richard Batterham
emerged as the foremost domestic British potter of the second half of
the century; and following his apprenticeship with Leach, Warren
MacKenzie's return to the United States proved hugely influential in that
country. Byron Temple, another American potter who arrived at St Ives in
1959, later became a dominant force in the USA. His premature death in

Earthenware dish by Alison
Britton, l: (approx.) 38 cm
(15 in). *Photo by Philip Sayer,
courtesy of Barrett Marsden
Gallery.*

2002 has served to elevate him to even greater significance with American
collectors of his work.

Whilst the 1950s can be thought of as Leach's decade, the 1960s and '70s
saw a move away from Anglo-Oriental forms towards a much freer experi-
mentation with form and colour. Rie and Coper must take a lot of credit for
this, if only because of their presence at London art colleges. Although their
own work was predominantly monochrome, they encouraged budding
potters to be expressive and let their work show their own personalities.
Coper and Rie both lectured at Camberwell School of Arts and Crafts (now
Camberwell College of Arts), just one of the colleges that introduced pottery
courses in this period. Through the new diploma in art and design, students
were encouraged to be individually creative and not necessarily just to
develop craft skills by repetitive work. As illustrations of this individualistic
and creative work, it is certainly worth having a good look at the ceramics of
Dan Arbeid, Gillian Lowndes, Alison Britton, Jill Crowley, Gordon Baldwin
and Elizabeth Fritsch.

Significant quantities of the work produced during this period were
merely 'à la mode', and when the trend passed so did the popularity of the
pots. Some, including the work of Rie and Coper and many of those
mentioned above, have a timeless quality and a beauty and strength of form
that makes them very like the pots aspired to by Leach – they 'sing'. Among
an increasing number of ceramics courses offered by universities and
colleges, it is fortunate that one college, Harrow, retained a spiritual
connection to the Leach ethos; a great many of our best potters benefited
from their training there.

Since the 1970s, despite the fact that many colleges still focus on
expression at the expense of technique, diversity has flourished and many
of the prejudices and arguments relating to Leach and the art-school focus
have been buried.

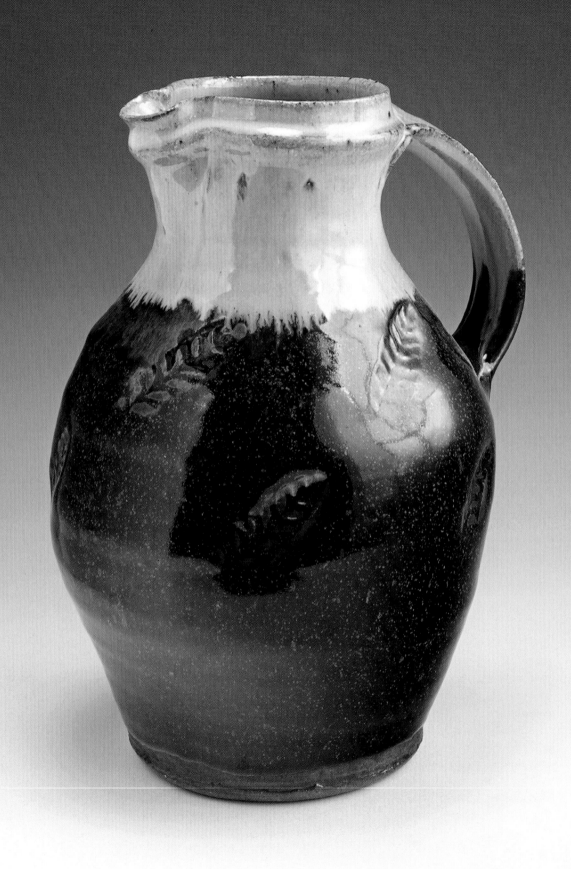

Why Collect Studio Pottery?

There are two main reasons for making collections of things: because you are passionate about them or for investment. To my mind, the passion should always come first, although it is also quite reassuring to find that the objects of your collection do not decrease in value.

Collecting for passion

There is little point in making a collection of anything at all unless you care deeply about whatever it is you have chosen to collect. Many collectors care so deeply about their subject that adding just one more item to the collection can become an overwhelming desire. Through relating it to my own passion, this section of the book deals with the purchase and acquisition of pots.

It is difficult to decide what it is about craftwork made from natural materials that is so appealing. If people have been lucky enough to have a background that has allowed them to make things from wood, cane, clay, cotton or wool, then it is likely that this will 'stick' and an affinity with these materials will be lifelong. Robin Tanner always said that if we allowed children to make, they would grow up to appreciate all manner of things and not want to destroy anything. I think there is a great deal of logic to his assertion. An appreciation of things surely comes from an interaction with and understanding of materials, and the self-satisfaction and pride in one's own achievement. In my case, I was lucky enough to have worked with all these materials before the age of 11, and thus an intuitive love of handmade

Opposite: Stoneware jug by Phil Rogers, ht: 26½ cm (10½ in). Tenmoku with nuka rim and impressed decoration. *Photo by David Binch, by kind permission of the artist, private collection.*

Above: Detail from bottle by the author *(see p.25).*

items must have become a part of my being. But why pottery? Maybe part of the answer to this question lies in the fact that of all the objects I created as a young child, I have only one photograph remaining, and that is of a clay eagle.

My epiphany as an adult came completely by chance. I was visiting an antiques fair looking for Windsor armchairs when I came across a stall consisting of two large tables, which were dominated by a large oatmeal-coloured charger measuring 43 cm (17 in) across. The colour varied from honey near the edges, where the glaze was thickest, to what I would describe as 'porridge' in the middle. I asked where it had come from, and the seller informed me that it was made by William Marshall at the Leach Pottery in St Ives. He asked me if I would like to take a closer look. Had I said no, I might have avoided the addiction, but I rather tentatively said yes and the seller passed it to me. The feel of the plate in my hands, its balance and substance, communicated something to me in a way that no other object had ever done before. I was hooked! I paid £80.00 for that large plate, which was far more than I had available. But something told me I had to have it, and, having bought it, my life was changed forever.

Oatmeal charger by Bill Marshall, dia: 43 cm (17 in). Stoneware. *Photo by David Binch, by kind permission of Marjorie Marshall, private collection.*

Two very similar yunomi by Jim Malone, ht: 9 cm (3½ in). Stoneware, with subtle variations of form and decoration. With hakeme slip and brushwork. *Photo by Alistair Hawtin, by kind permission of the artist, private collection.*

At that time, I had no idea what the Leach Pottery was or, indeed, who Bill Marshall was, but it did not matter. The pot was mine, and I was now a collector of pots.

Several years later, I met David Attenborough, who is well-known to be a collector of ceramics, in particular the work of Lucie Rie, of whom he once made a fascinating film biography. He said to me, 'So you collect pots, do you? It's a disease, isn't it?' Well, I am not sure that I would describe the deep affection that I have for pottery as a disease exactly, but there is certainly something about the endless variety of artistic expression to be found among pots that grips the imagination. It drives one to seek further examples with subtle variations of form or glaze or colour. It is also the tactile quality of pots, the feel of them, which makes them so attractive. When you hold a pot that feels just right, you know it through the weight, the balance, the quality of the form and the texture of the glaze.

Ceramics also provide the direct and sometimes overwhelming contact between one human being and another that often transcends decades and even the end of a potter's life. I love that feeling of involvement when the pleasure a potter has experienced in creating an object transmits itself to me and in a small way allows me to gain an insight into his or her life. A pot is a tangible object that represents a moment in a potter's life frozen forever, the expression of an idea that once fired (and barring accidents!) is there for eternity. The object can be placed in context in a potter's working life, and represents a small part of that life and creativity. There is also a cultural history in which the pot plays a small part as an example of a period, a particular kiln or a particular mix of glaze or clay. It can be read almost like a book. The potter made the pot, fired it and then held the pot in his or her hands, and then perhaps years later I have held and admired the same pot in a way that cannot be done with a painting. Even if I have owned a pot for

Marmalade jar by Bernard Leach, ht: 12½ cm (5 in). Note the symmetry of form but asymmetry of decoration, the pigskin quality of the glaze, and the use of the pale-blue background colour to emphasize the beauty of the brushwork. *Photo by David Binch, by kind permission of John Leach, private collection.*

years, I can contemplate it afresh in a slightly different light, picking up a hitherto-unnoticed glaze effect or nuance of form, and wondering if the potter saw this as I have. Just for that moment, it is as if the two of us are sharing the same experience.

Pots as art objects have a three-dimensional quality which one seldom finds in painting, and often a sense of beauty born out of function that most fine art, including sculpture, cannot possess. Bernard Leach once said, 'The man is the pot', and it is true that the very best of studio pottery incorporates both the discipline of utility and the personality and attitudes of the people who made them. Pottery can be handled and enjoyed in the same way that sculpture is meant to be enjoyed – in a tactile as well as a visual way – but the advantage of being functional makes it doubly attractive! Later I shall expand on the merits of function versus the purely decorative, if indeed there is such a thing. For me, however, function is an important and wholly integral element in my attraction to pottery, and thus I use many of my pots on a regular basis.

Another no-less-significant reason for collecting pots is the price! Pots are usually significantly cheaper than the best fine art.

Since I began collecting pots, I have also started to make them. I discovered, as if for the first time, the mesmerising delights of watching the spinning

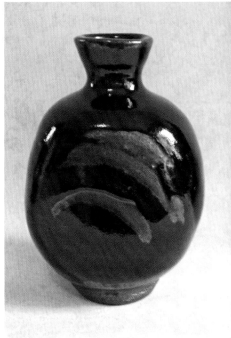

Above right: Bottle by the author, ht: 14.5 cm (5¾ in). Made from heavily grogged clay with black iron oxide under a tenmoku glaze. *Photo by Alistair Hawtin.*

Above left:: Earthenware tankard by Geoff Fuller, ht: 14 cm (5½ in), with Janet Leach porcelain stem dish holding tomatoes, (and plastic beer bottle). *Photo by Alistair Hawtin, by kind permission of Geoff Fuller and Crafts Study Centre, 2008. Private collection.*

potter's wheel and feeling the clay being moulded into shape under my fingers. Strangely enough for someone who normally has little confidence about tackling new ventures, I never doubted for a moment that I would be able to pot, and I found that I could!

Through my passion for pottery, I have had the great good fortune to meet many delightful and charming people, including the aforementioned Bill Marshall, and I am now fortunate to count many fellow collectors and potters as my friends. It is extremely common to find that people connected with the contemporary ceramics scene are genuine, friendly, honest and passionate people of great integrity, who often possess a remarkable aesthetic sense for studio pottery. Elsewhere in the book, through interviews I have conducted, I hope to give readers more of an insight into collectors as a breed, but at this point I would like to mention one man with a far greater passion for pots than anyone else I have ever encountered. His name was Bill Ismay, and he can best be described as the collectors' collector!

What a man Bill was – his dedication to pottery and to potters made other collectors seem like mere amateurs. Through his collecting, Bill became a great supporter of living potters, to the extent that he was the one collector in whose collection every potter craved to be represented. A purchase by Bill Ismay was almost a confirmation that a potter had made it – a seal of approval, a potter's royal warrant.

Bill Ismay, collector extraordinaire, in writing about his own collecting habits made the following observation: 'The main and simple principle on which I collect is to like the pot I am acquiring (for reasons based on the

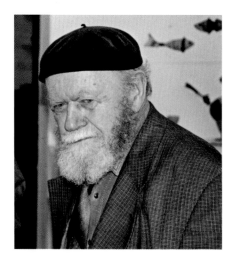

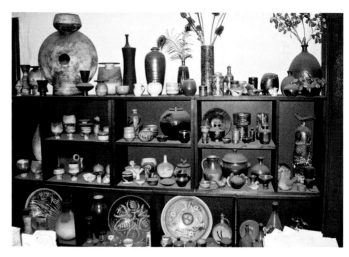

Above: Bill Ismay, collector extraordinaire. *Photo courtesy of Tony Hill.*

Above right: Inside Bill Ismay's house. Examples of work by many major artists are visible, including several pieces by Hans Coper. *Photo courtesy of Tony Hill.*

handling of thousands of pots previously) and to be able (sometimes only by stretching resources) to afford it: this automatically rules out anything above a certain price-level, but working to a limited budget without ever having been affluent, and achieving any minor extravagance simply by going without other things, is not without its rewards as well as its limitations: collecting should not be too easy.' (From unpublished speech 'W.A. Ismay: Ever the Potter's Friend' by Tony Hill, September 2001, see Bibliography.)

Bill Ismay, by profession a librarian, lived in a small terraced house in Welbeck Street in Wakefield. His ultimately vast collection was assembled from 1955 onwards, and by the time of his death, in 2001, he had amassed a collection of over 3500 pots, representing the work of some 500 potters. Even though he had many pots by potters who were no longer alive, his guiding principle was to find living potters whose work he liked and then to support them by buying their best pots. He usually bought from exhibitions and could frequently be found standing outside the gallery well before the exhibition was due to open, with his beret on his head and his bag in his hand. The old leather shopping bag contained, amongst other things, a magnifying glass for examining pots in great detail. Bill's collection, now based in the Yorkshire Museum and Art Gallery, includes marvellous pots by, amongst many others, Bernard Leach, Shoji Hamada, Hans Coper, Lucie Rie, Jim Malone and Phil Rogers. His passion for pots was unrivalled. As his collection grew, the available space in his home shrank about him, until the only usable space was a corner of his kitchen table where he both ate and worked. He was much respected and loved by the potters whose work he collected. He was also a perceptive, amusing and generous man. Bill was awarded the MBE in 1982 for services to studio pottery.

If you can already identify with the feelings about ceramics mentioned here, you will already be a collector; if not, there is a good chance that, as you are reading this book, you may want to try out a few pots to see if they 'speak' to you. Not all pots will, but, if you are lucky like me, you will find your own Bill Marshall charger.

An interview with David Binch of Oakwood Ceramics

Q. What drew you to collect studio pottery in the first place?

A. *I first noticed pottery by chance when I came across an exhibition of pottery by William Moorcroft. This was the starting point of a 30-year continuing journey. It led subsequently to the words and work of Bernard Leach, and showed me the path and lit the fire. Pots, like pebbles picked up on a beach, were acquired along the way.*

Q. Which potters do you most admire and why?

A. *I admire the unknown potters from the 12th–14th centuries – China and Korea, but also in Medieval England – who created some of the true masterpieces of the potter's art. Above all, these pots were produced without any hint of the individual ego, with no personal marks; no ego, just pure form created for purpose.*

Q. What criteria do you use when selecting which pots to buy?

A. *The pots I buy are selected for their quality – for me it's 100% aesthetic. My taste is quite narrow, mainly stoneware and porcelain, thrown and glazed with the classical stoneware glazes, mainly tenmoku and celadon. If the potter gets it right, then I listen for the voice of the pot to speak to me. Some of my most cherished pots cost hardly anything and are tiny. For instance, a small bud vase by Katharine Pleydell-Bouverie was saved from a charity shop for a pound. If my house was on fire and I could only save one piece, the KPB would be my choice.*

Q. Of current potters, whose work do you think will be the antiques of the future?

A. *This is a difficult question and one of the most frequently asked. I always answer in the same way: buy to own and to enjoy and not for speculation; others will be the judge, fashions change, and popularity waxes and wanes. I think that Ewen Henderson did some good work and I hope history will judge him kindly. Bill Marshall and Jim Malone have best captured the Hamada/Leach philosophy of spontaneity and form. I think good pots by all three will be sought after in the future.*

Q. Which little-known potters would you recommend people investigate?

A. *This is perhaps the hardest question, as we now live in an age of mass media where through the internet you can quickly find hundreds of little-known potters, all of whom are doing their best. Most are not going to produce work of lasting value. My hope is that young potters will appear and stay around long enough to make some good pots. Amanda Brier and Yo Thom may fulfil the promise currently shown.*

Q. Which pots would you consider iconic studio pots?

A. *My first is the squared wax-resist bottle vase with stem pattern by Shoji Hamada in the V&A Collection. I first saw it nearly 40 years ago, and once seen it is never forgotten. Second is a winged porcelain pot with a stunning blue-green celadon by Colin Pearson, made in 1971. It reminds me of, and I think is inspired by, the Longquan Mallet vases with phoenix handles, so admired by the Japanese tea masters. Third is a fluted teapot by David Leach, exquisite in every way and instantly recognisable.*

Collecting as an investment

For some, investment will be the main reason for compiling a collection of studio pottery. If this is the case, it seems to me a shame that something can be collected without any kind of insight into, or appreciation of, the aesthetic merits of pottery. However, for most the financial value of the pot will be secondary to the pleasure derived by being able to see and handle a beautiful object on a regular basis in the surroundings of one's own home.

If you are interested in the current value of pots, short of visiting an auction house such as Bonhams in New Bond Street, London, the best source of information is to read catalogues of the most recent auctions. Antiques guides often have examples of studio pottery included, though frequently these are random examples that may well be untypical of a particular potter's work. Importantly, a collection of auction catalogues will inform you of trends, and these are far more important than straightforward values, as one will need to know which potters' works are going up or down in value. The disadvantage of all these sources is that they tend not to show pots that are most typical of a potter's everyday output.

A home enhanced by contemporary ceramics. Bottle by Bill Marshall, ht: 44 cm (17¼ in), with celadon fluted bowl by David Leach, dia: 13 cm (5¼ in). *Photo by David Binch.*

What is the true value of a pot anyway? One look at an internet auction site will show you how much and how frequently items can fluctuate in price. Bidding in online auctions or lesser provincial auctions is a good way, if you are lucky, to pick up a bargain. It is also a good way to buy purely functional ware at reasonable prices.

As it happens, studio pottery has become a major player in the investment arena. Certain pots made by Hans Coper were selling for £100 back in 1972. Were you to try to buy a similar one now, you might expect to pay in the region of £5,000! Be aware, though, that some other potters whose work sold for several hundred pounds in 1972 only sell for a similar figure now, or perhaps even less. So how can we work out which pots are the best investment?

Potential investors have three courses of action. Firstly, one can play safe. For example, Bernard Leach usually made pots of sublime beauty according to traditional criteria, and his pots have gradually increased in value over the years. I have the original receipt for a Bernard Leach slab-built bottle, which first sold for £20 in 1970 and was bought by me

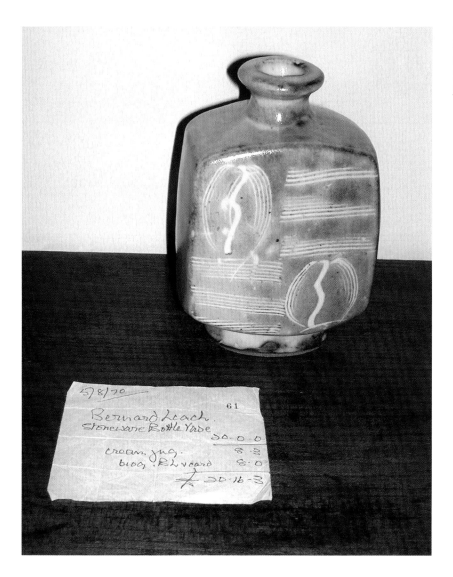

Slab bottle (with receipt) by Bernard Leach, ht: 19 cm (7½ in). *Photo by Alistair Hawtin, by kind permission of John Leach, private collection.*

for £1,500 in 2001. Another tall, elegant bottle vase sold for £210 at auction in 1978, and a similar one sold for £3,200 in 2006. Shoji Hamada's pots and those of Michael Cardew, Peter Voulkos, Lucie Rie and Hans Coper have also considerably increased in value. A Lucie Rie vase sold for £300 in 1981, while a similar one sold for a little short of £3,000 in 2006. In 1979, the estimate at auction for a black Hans Coper spade form was £500–700, but a comparable one sold for £13,000 in 2005!

Despite the fact that nowadays it would cost a lot to buy a good example by any of these potters, they are still likely to be a solid investment and to suffer only minor fluctuations in value. Because of their historical importance to the development of the studio pottery movement and the relative rarity of their best work, this work will almost certainly always be valued by collectors.

Yunomi (top) by Warren MacKenzie, ht: 9 cm (3½ in), with orange shino glaze; (bottom left) by John Maltby, ht: 9 cm (3½ in), with applied decoration; and (bottom right) by Phil Rogers, 9.5 cm (3¾ in), salt-glazed. *Photo by Alistair Hawtin, by kind permission of the artists, private collection.*

A second course of action is to buy the work of living potters whose pots are currently highly rated. Into this category would fit, for example, John Maltby, Phil Rogers, Janet Mansfield, Jim Malone, Elizabeth Fritsch, Gordon Baldwin, Alison Britton and Warren MacKenzie – all examples of potters who are also contributing significantly to contemporary ceramics and whose work demonstrates a quality of workmanship that sets it apart. It is still possible to buy their pots at relatively low prices.

A third possibility would be to invest more speculatively in potters whose work is currently not that expensive but, due to the quality of their work, or their limited output, or the nature of the work they produce, could be far more valuable in the future. Into this category I would put Sarah Walton, Ian Gregory's sculptural work, Emma Rodgers, Geoff Fuller, James Walford and Poh Chap Yeap. The last two are particularly interesting because their work sold for higher prices in the 1970s than it realises now. Of course, there are many potters coming into the marketplace every day, and it is quite exciting to discover a new potter whose work appears to be both good in quality and has something interesting to say. However, I would offer a word of caution: expensive pots bought now do not mean expensive pots to sell in the future. The future will be littered with lost reputations and work that has little or no resale value.

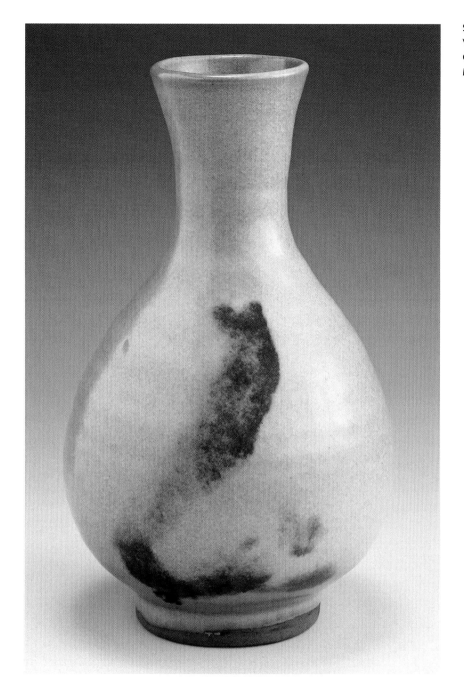

Stoneware bottle by James
Walford, ht: 20 cm (8 in).
Chun glaze. *Photo by David
Binch, private collection.*

In my opinion, works by all the potters mentioned above are the potential 'antiques of the future', that is, ceramics whose quality in the making is vital and unquestionable, made by potters whose work has had something to contribute to the development of the movement. Interestingly, in an interview, Henry Sandon of the BBC Antiques Roadshow chose a Phil Rogers pot as one of his antiques of the future.

Whose Work Should I Collect?

This is an extremely subjective decision to make. I have already discussed collecting for passion and collecting for investment, and the criteria you use to guide the development of your collection will naturally influence the direction you follow.

At any one time, there are some potters whose work is already deemed much more significant than that of others. Although prices tend to fluctuate considerably, it takes the occasional book or exhibition to lift the prices of the less well-esteemed group, while some potters' work seems to hold its value, despite the vagaries of the global market. Understandably, many of the potters whose work retains its value are no longer living, but there are some living ones whose work is already considered highly desirable. Some I have already mentioned, but below, as a guide for those interested in beginning collections, I have compiled a more comprehensive list.

Any selection by an individual collector is bound to be entirely subjective. My list of the top collectable potters who are no longer living is shown simply in alphabetical order (rather than any kind of hierarchy). They all worked predominantly in the United Kingdom, unless otherwise stated.

Above: Detail from *Space Map* by Regina Heinz. *Photo courtesy of Ceramic Review Publishing.*

Oppposite: Winged vessel by Colin Pearson, ht: 22 cm (8¾ in). Pearson often used to work in porcelain as well as stoneware. *Photo by David Binch, by kind permission of the artist's estate, private collection.*

Right: Korean-style vase by Malcolm Pepper, ht: 16 cm (6¼ in). Porcelain. Pepper made exquisite Korean-influenced vases. His work has become very collectable, in part due to the fact that he died young. *Photo by David Binch, private collection.*

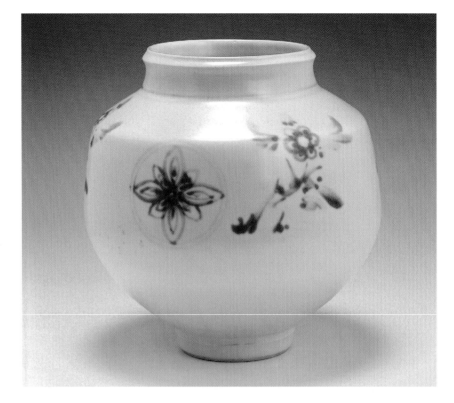

Below: Porcelain bowl by Geoffrey Whiting, dia: 16 cm (6¼ in). Geoffrey Whiting was best known for his teapots, but his brushwork was also of a very high standard. *Photo by David Binch, by kind permission of David Whiting, private collection.*

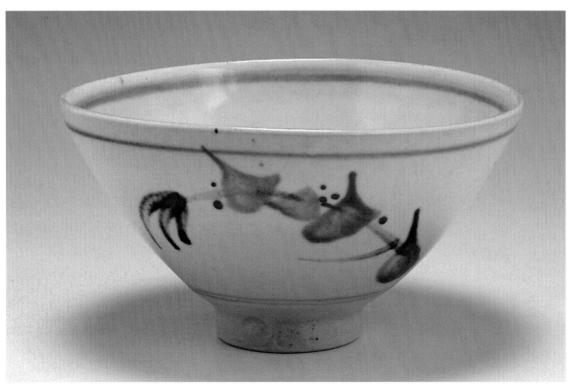

Agnete Hoy
Bernard Leach
Byron Temple (USA)
Charles Vyse
Colin Pearson
David Leach
Derek Emms
Edward Hughes
Ewen Henderson
Geoffrey Whiting
Hans Coper
Harry and May Davis
Henry Hammond

Ian Godfrey
James Walford
James Tower
Janet Leach
Joanna Constantinidis
John Reeve (USA)
Katharine Pleydell-
 Bouverie
Kenneth Quick
Ladi Kwali (Nigeria)
Lucie Rie
Malcolm Pepper
Michael Cardew

Mick Casson
Norah Braden
Peter Voulkos (USA)
Rosanjin (Japan)
Rudy Autio (USA)
Sam Haile
Shoji Hamada (Japan)
Tatsuzo Shimaoka
 (Japan)
William Marshall
William Newland
William Staite Murray

Compiling a list of living potters whose work is already collectable or likely to become collectable in the future is even more subjective and risky, but below is my current list. They all work in the UK unless otherwise stated. If it only serves as a subject for debate, I shall be satisfied.

Stoneware plate by Ray Finch, dia: 38 cm (15 in). *Photo by David Binch, by kind permission of the artist, private collection.*

Aki Moriuchi
Alan Caiger-Smith
Alison Britton
Antonia Salmon
Bodil Manz (Denmark)
Christy Keeney
Claudia Casanovas
 (Catalonia)
Dan Kelly
David Frith
Edmund de Waal
Elizabeth Fritsch
Elizabeth Raeburn
Geoff Fuller
Geoffrey Swindell
Gillian Lowndes
Grayson Perry
Gordon Baldwin
Gutte Eriksen
 (Denmark)
Gwynn Hansen-
 Piggott (Australia)
Ian Gregory
Janet Mansfield

(Australia)
Janice Tchalenko
Jason Wason
Jim Malone
Joanna Howells
John Maltby
Kate Malone
Ken Matsuzaki (Japan)
Lisa Hammond
Magdalene Odundo
Margaret Frith
Marianne De Trey
Martin Smith
Micki Schloessingk
Mike Dodd
Nic Collins
Nigel Wood
Phil Rogers
Poh Chap Yeap
Ray Finch
Richard Batterham
Ruth Duckworth
Ryoji Koie (Japan)
Sarah Walton

Shinsaku Hamada
 (Japan)
Shiro Tsujimura (Japan)
Sutton Taylor
Takeshi Yasuda
Wally Keeler
Warren MacKenzie
 (USA)

Right: Pots by contemporary potters, including rope-pattern plate by Shimaoka (recently deceased), (dia: 28 cm/11 in), lustre dish by Caiger-Smith (24 cm/9½ in), teapot by Nigel Lambert, Bird with Fish by John Maltby and Hare by Geoff Fuller. *Photo by Alistair Hawtin, by kind permission of the artists, private collection.*

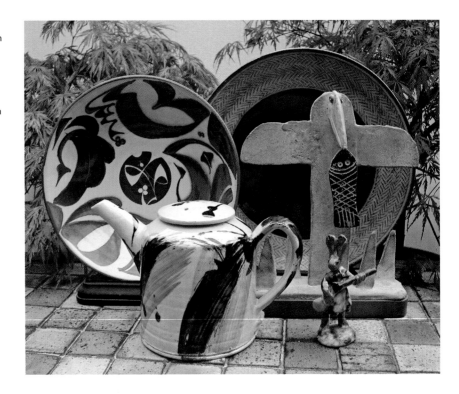

Below Gold bowl by Emma Johnstone, ht: 6 cm (2½ in). Raku form. *Photo courtesy of Ceramic Review Publishing.*

Work by Sun Kim, a Korean potter working in England. *Photo courtesy of Ceramic Review Publishing.*

Most of the potters listed on p.35 are well-established names, but it is worth speculating on some less familiar names that have great talent. Of course, this list changes daily as new potters appear, but in my opinion those listed below are very worthy of investigation.

Two bowls by Matthew Blakely, dia: 17 cm (6¾ in) and 18.5 cm (7¼ in). *Photo courtesy of the artist.*

Angela Verdon
Anne Mette Hjortshøj (Denmark)
Carina Ciscato (Brazil)
Daniel Smith
Eddie & Margaret Curtis
Emma Johnstone
Emma Rodgers
Gitte Jungersen (Denmark)
Gordon Crosby
Hayley Daniels
Helen Beard
Jonathan Wade
Kang Hyo Lee (South Korea)
Marit Tingleff (Norway)
Matthew Blakely

Mina Rusk
Murray Cheesman
Niek Hoogland (Holland)
Nigel Lambert
Paul Young
Philip Revell
Prue Venables (Australia)

Rob Barnard (Australia)
Regina Heinz (Austria)
Susan Disley
Sun Kim (South Korea)
Tae-Lim Rhee (South Korea)
Tomoo Hamada (Japan)
Yo Thom

Space Map by Regina Heinz,
w: 32 cm (12½ in). Stoneware.
*Photo courtesy of Ceramic
Review Publishing.*

Amongst the various potters listed, there have been and continue to be many whose lives are spent producing functional ware for everyday use. Many of them have also made individual pieces. Their work is of the highest quality, and I feel convinced that in future years it will be much more highly regarded. Some favourite practitioners of mine among the many on these lists are Harry and May Davis of the Crowan Pottery in Cornwall, and later at Crewenna Pottery in New Zealand; Richard Batterham, whose pottery is at Durweston in Dorset, close to Bryanston School, which he attended as a boy; and Janice Tchalenko, who has produced some beautiful and colourful work as an individual, but also for the Dartington Pottery, for whom she worked as designer. John Leach, Bernard Leach's grandson, from Muchelney in Somerset, has continued to produce some attractive wood-fired domestic ware for the past 40 years, while other personal favourites include Micki Schloessingk who works in South Wales and makes the most superb jugs, and three potters from Gloucestershire, England: Nigel Lambert, whose colourful, vibrantly decorated earthenware is a delight to eat off, being both highly functional and attractive; John Jelfs, whose teapots are amongst the best in Britain; and Ray Finch, who owns and runs Winchcombe Pottery.

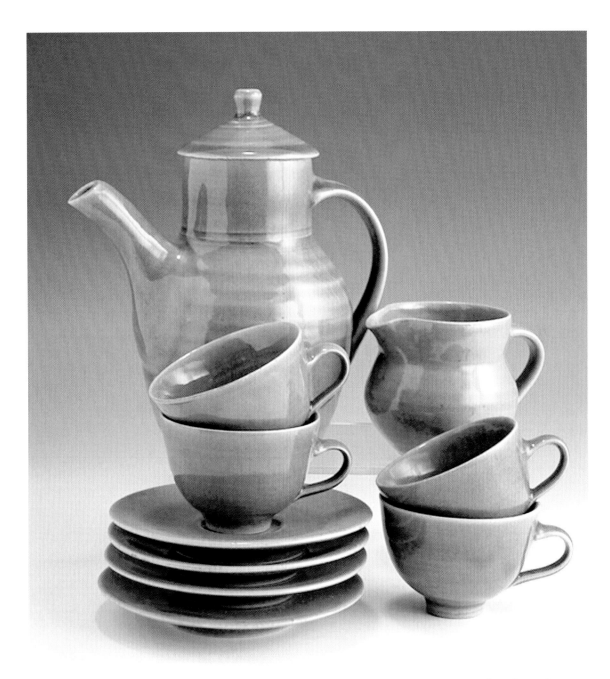

Pots from Crowan Pottery by Harry Davis, ht: (coffee pot) 16 cm (6¼ in). Harry Davis used to boast that he could stand on his plates without them breaking. *Photo by David Binch, private collection.*

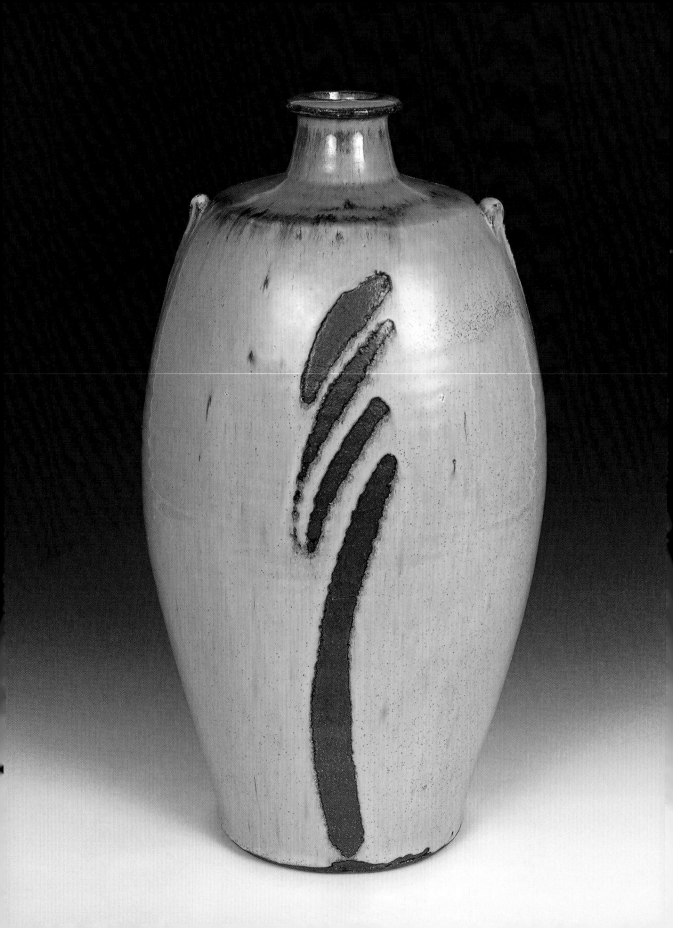

How Do I Start Collecting?

One of the biggest traps a collector can fall into is becoming too eclectic. There is really no short cut to developing an eye for a good pot: and the new collector of studio ceramics will need to be prepared to spend some time and money making mistakes, before coming to a clear view of what is generally considered to be a good pot that will also be pleasing. My loft is full of mistakes, and many charity shops have benefited as I have become more discerning!

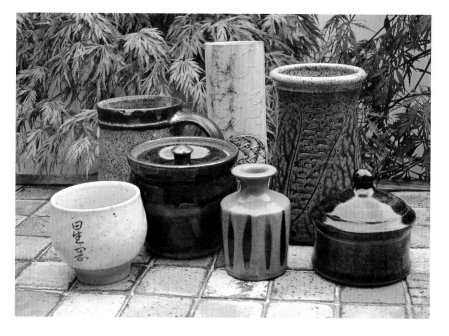

Left: The type of pots that fill my loft. *Photo by Alistair Hawtin.*

Above: Detail from pot by unknown maker.

Opposite: Nuka ash-glazed bottle by Phil Rogers, ht: 41 cm (16 in). The majestic proportions of this pot give it grandeur, while the spontaneous decoration compliments the form perfectly. *Photo courtesy of the artist.*

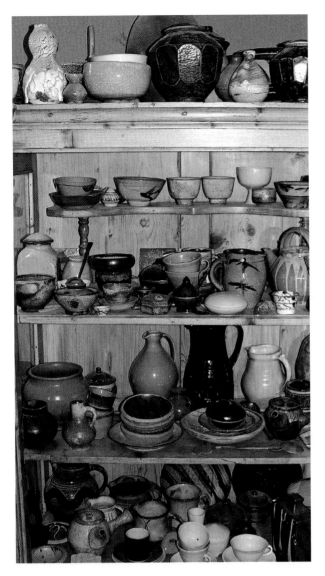

Above: This glass-fronted display cabinet is ideal for showing off work (glass door is open in this image), but beware of too much clutter! *Photo by Phil Rogers.*

To avoid the danger of allowing your collection to be too general, it is advisable to take control of your collecting at an early stage. However, some pitfalls are unavoidable, and it is only through making mistakes that one refines one's taste and begins to 'know' a good pot. It is also likely to take a while before you are fully aware of the type of pot that most appeals to you. I would advise approaching the matter with some degree of caution. Some of the many issues you will encounter are discussed in the next few pages.

Firstly, think about what it was that appealed to you about the pots you were initially attracted to. Was it their colour, feel, size or shape, or maybe the way they were made? Was it their functionality or their decorative qualities? Of course, it is likely to have been a combination of more than one of these. By engaging in this minor self-examination, you may be able to refine your collection before beginning.

Clearly, your taste in other directions will influence the direction your pot-collecting takes. If you like bright colours, you may be tempted by highly decorated pots. On the other hand, if you prefer muted colours, you may want to focus on ash-glazed pots in greens and browns. Minimalist living spaces with white walls are well suited to groups of pale celadon porcelain pots in white, green or blue, and some collectors do select pieces according to what suits their physical surroundings. For example, if you are limited by the amount of space you have for display, or you share your house with someone with very different tastes, these factors may well dictate what you are able to collect!

An interview with Stephen Sell, collector and potter from the USA

Q. What drew you to collect studio pottery in the first place?

A. *I took a pottery class at a local arts & crafts centre and immediately fell in love with the medium. In my pursuit of understanding the relationship between form, function and decoration, I began researching books and examining any pots I could get my hands on.*

Q. Which potters do you most admire and why?

A. *Warren MacKenzie's work was some of the first studio pottery I had the opportunity to handle and study. It is timeless and speaks to truth and beauty. Mick Casson's pots, especially his jugs, exhibit a strength and truth that appeal to me.*

Q. What criteria do you use when selecting which pots to buy?

A. *My collecting style and focus have changed over the years. My current thought process is as follows: Do I like it? Is it a signature piece or exhibition-quality piece? Does it fit my collecting focus? Finally, if you really like a pot, go for it; you only regret the pot that got away!*

Q. Of current potters, whose work do you think will be the antiques of the future?

A. *I would recommend Warren MacKenzie, Ken Ferguson, Tatsuzo Shimaoka and Edwin Scheier. In general, when collecting pots, I acquire the best examples of a given potter's body of work, their signature pieces.*

Q. Which little-known potters would you recommend people investigate?

A. *Japanese Potters: Koji Kamada (tenmokus), Minegishi Seiko (celadons).*

Q. Which pots would you consider iconic studio pots?

A. *Edwin Scheier's decorative chalice forms, Warren MacKenzie's simple shino bowls, and Ken Ferguson's pots from his 'Hare' handle series.*

Recognizing by Style and Developing an 'Eye' for a Good Pot

Each of the potters featured in this book has developed a distinctive and personal style of work. If you want to collect pots by particular potters, you will have to begin to recognize them by their style, as you cannot always rely on the potter's mark. In some cases, pots are not marked because the potter has a policy of not marking his or her work. Clive Bowen and Richard Batterham are two good examples of potters who do not mark their work because they feel its style and content are distinctive enough not to need a signature. Sometimes a potter can quite simply forget to stamp his work! With many potters, the style is very easily recognizable, but with others it is much more difficult. One of the biggest dangers in purchasing unmarked works is being fooled by a seller who either knowingly or mistakenly claims a pot to be by a famous potter. In the absence of evidence to confirm the authenticity of a pot one must rely on your own ability to identify it by style, and this can only be developed through experience.

Amongst the most common attempts at deception are pots claimed by sellers to be by Bernard Leach and those claimed to be by Hamada. It is often simply ignorance on the part of sellers that allows them to claim that a Leach Pottery piece is by Bernard. Unless a pot has the BL mark on, beware! Even if it does have a BL mark on it, be wary unless there is either good provenance or you are very satisfied with the style of the piece. If it is a decorated pot, check this out carefully. Even Leach's later decoration was usually very spontaneous and displayed his genius for draughtsmanship.

Above: Detail from bottle with leaping fish decoration by Bernard Leach. *Photo by Phil Rogers, with kind permission of John Leach.*

Opposite: Unmarked container by Richard Batterham, ht: 24 cm (9½ in), whose work is so distinctive that he does not need to apply a potter's seal. *Photo by Alistair Hawtin, by kind permission of the artist, private collection.*

Yunomi pot by Hamada
(ht: 9 cm/3½ in), and a
yunomi by another maker
from Mashiko. Note the
similarities and differences,
particularly in the finger wipes.
*Photo by Alistair Hawtin, by
kind permission of Tomoo
Hamada, private collection.*

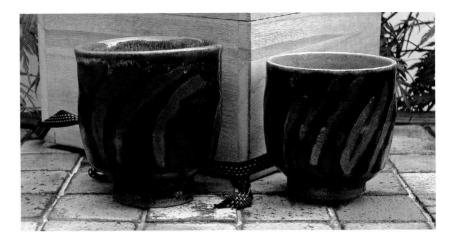

Beware of sellers claiming pots are by famous potters such as Hamada, particularly if using an online auction site. For example, Hamada worked in Mashiko in Japan, and very often work by other Mashiko potters using the same glazes and methods of decoration is claimed to be by Hamada. Trust your own judgement and knowledge. If in doubt check the foot-ring; ask for a photograph and compare it with a known foot-ring by that particular potter – this will tell you more than the decorated surface ever could.

This assertion requires some qualification. The foot-ring on a pot is something a forger will not have seen very often. Most people eager to deceive will have only seen a pot by a famous potter standing on a shelf or illustrated in a book, with no access to what's underneath. Trying to make up the underside of a pot is not easy, so errors often occur. How can you tell whether a foot-ring is right or not? The only way is to look carefully at the foot-rings of genuine pots, and this can only be done by seeing and handling

(From left to right, and top to bottom), foot-rings on pots by the author, Phil Rogers, Mike Dodd, Shinsaku Hamada, Shoji Hamada, Bill Marshall, Kenneth Quick.
Photo by Alistair Hawtin, private collection.

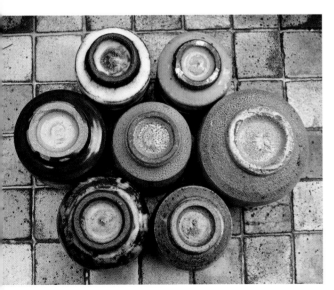

the real thing. Although this ability to use the foot-ring as a means of identification is only something that can be developed after a certain amount of experience, I cannot stress enough how useful it is.

One of the best ways of getting to know pots is to handle as many as you can as often as you can. You will develop a feel for what is right and, by using all the senses, you will learn to recognize the styles of different potters. Exhibitions and auction houses would be well worth a visit. You could even try drawing some of the designs that a potter uses to decorate a pot, whether it is a brushwork design or a particular form, or something scratched into a pot. Sketching the dimensions and the various features characteristic of certain pots will help imprint in your mind the different styles and approaches of various potters so that you are better able to decide

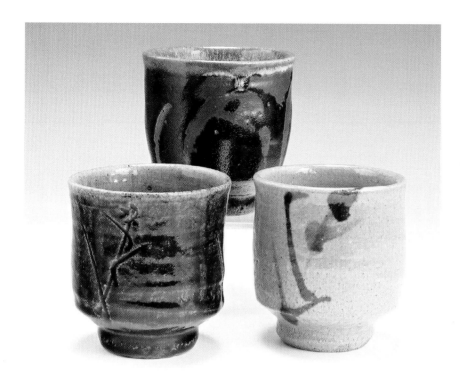

Hamada designs. On the two lower yunomi Hamada's distinctive corn stalk design is shown, one incised, the other painted. Ht: (left to right) 8½ cm (3¼ in), 9 cm (3½ in), 9 cm (3½ in). *Photo by David Binch, by kind permission of Tomoo Hamada, private collection.*

the attribution of an unsigned or spuriously accredited piece of work when you come across it.

In summary, if you are trying to gain an 'eye' for a good pot:

- At every opportunity pick up and feel pots to gain an understanding of weight and balance.
- Check the balance. It should be right, not too heavy at the top or the bottom – particularly the bottom, as that is where the clay has been moved from in the throwing.
- Feel for an even thickness throughout the pot; good potters pot evenly!
- Look at and feel rims. As a rule, these should not be too thin. Thin rims are often the mark of amateur throwing.
- Avoid pots that look as if the potter has run out of clay before making the neck. A neck that appears too short or too thinly potted is the mark of a poorly made pot.
- Study the style of decoration a potter uses, perhaps even sketching some designs yourself.
- Look at foot-rings, noting how these have often been cut spontaneously and with clear definition. Bad foot-rings mean bad potting.

Corn pattern design by Hamada, this time on a bowl, dia: 16 cm (6¼ in). *Photo by Phil Rogers, by kind permission of Tomoo Hamada, private collection.*

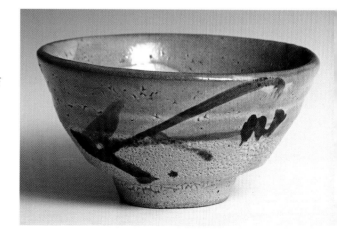

An interview with Phil Rogers, Welsh potter and collector

Q. What drew you to studio pottery in the first place?
A. *Bernard Leach's* A Potter's Book *and the feeling … once I had touched clay … that here was something I could become good at with practice.*

Q. Which potters do you most admire and why?
A. *I admire Korean potters of the 15th and 16th century, certain Chinese pots (usually of the Song period), German late-medieval salt glaze, English medieval jugs and 17th- and 18th-century slipware, and some of the 18th-century Settler pottery from the American East Coast. More recently, Bernard Leach, Shoji Hamada and even more recently Richard Batterham, Ray Finch, Lee Kang Hyo and Choi Sung Jae from Korea, Ruggles and Rankin, Linda Christianson and Byron Temple in the USA. I often see pots I admire, particularly from abroad, without knowing who made them.*

Q. What criteria do you use when selecting which pots to buy?
A. *I buy for myself only pots that I like. If my choices become more valuable over the passage of time then that is a bonus. I buy pieces by Shoji Hamada and Bernard Leach because I find them inspirational and because of their historical importance. I might buy a pot that I was not so fond of if it held a particular interest historically for some reason. Buying for investment is not to be decried, although I think it is more the domain of the experienced and knowledgeable.*

Q. Of current potters, whose work do you think will be the antiques of the future?
A. *I think that Richard Slee would be one. I think Walter Keeler would be a candidate, as well as Gordon Baldwin, Grayson Perry, Richard Batterham, Peter Beard, Ian Gregory, Mike Dodd, Lisa Hammond, Alison Britton and Magdalene Odundo.*

Q. Which little-known potters would you recommend people investigate?
A. *Ken Matsuzaki from Japan is an excellent potter whose work will become better-known as knowledge of it spreads. The same would apply to Lee Kang Hyo from Korea, a master of his craft.*

Q. Which pots would you consider iconic studio pots?
A. *There are so many. The Hamada bottle with wax-resist decoration in Liverpool's Walker Gallery is a stunning example of his work. Bernard Leach's fish-decorated vases and press-moulded bottles. I think that Lucie Rie's 'knitted bowl' and Hans Coper's 'balancing act' pieces also qualify, although they're not my taste. If I could own only one pot, it would have to be something by Shoji Hamada.*

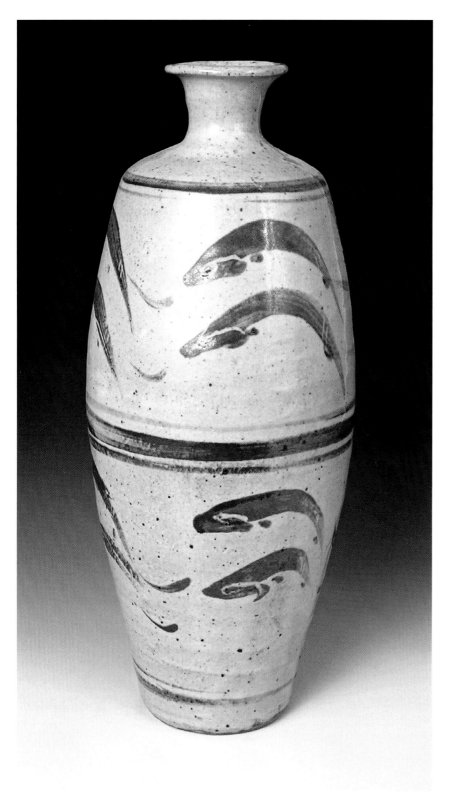

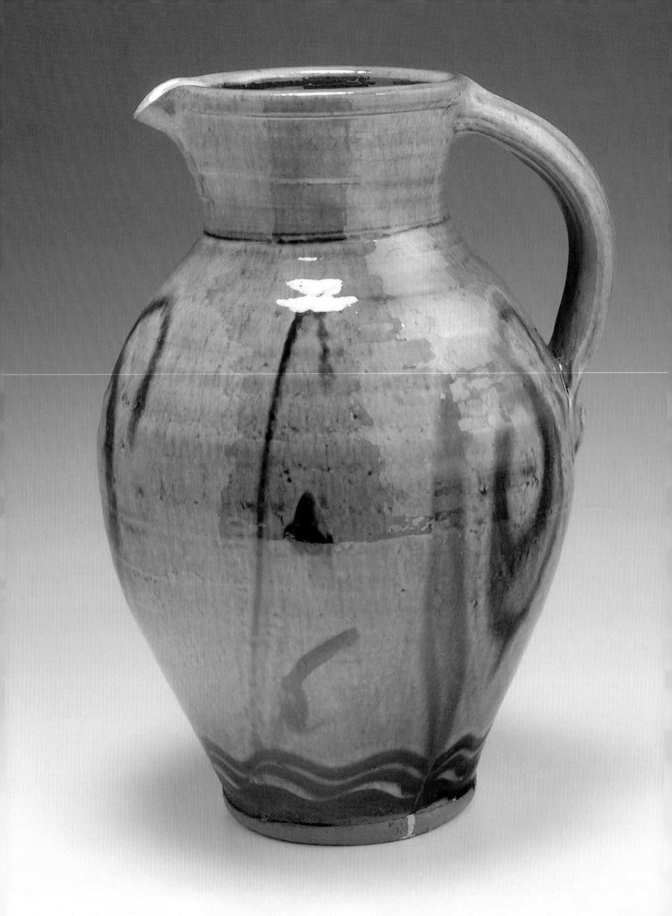

Which Types of Ceramics Should I Collect?

There are so many types of pottery available, and so many makers, that it is important to make some decisions about what to collect in order to allow you to focus on a particular genre or category of pottery. You may find you have a particular liking for slipware, or porcelain, or perhaps salt glaze, or stoneware. Maybe you will gravitate towards wood-fired pottery or highly decorated pieces, or the more oriental-influenced austere glazes made from wood ash. You will find descriptions of these in the glossary. After a little while, you will begin to garner some idea of what it is about certain types of pottery that appeals to you. Certain pots will communicate with you on a very personal, and some would say spiritual, level, and the secret of building a significant and satisfying collection is to listen to your instincts, understand the language and begin to build a knowledge base around your particular interest area. A focus to your collection will bring cohesion to the display.

Although this may be a good working rule, and one that Bill Ismay seemed to believe in, the great Yorkshire collector did not stick to it rigidly, which perhaps was why collecting pots took over his life so completely. He wrote, 'I have if anything a prejudice in favour of a pot which pleases me and is also useful (or rather, which in part pleases me for this reason) – but I am prepared to be interested in anything which seems to me to be a lively use of clay, although the result may be only notionally useful, or purely sculptural.'

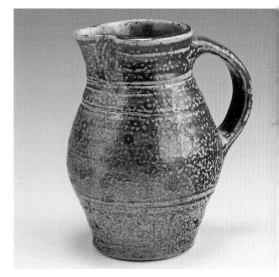

Above: Salt-glazed jug by Sarah Walton, ht: 14 cm (5½ in). *Photo by David Binch, by kind permission of the artist.*

Opposite: Earthenware jug by Clive Bowen, ht: 30 cm (11¾ in). *Photo by David Binch, by kind permission of the artist, private collection.*

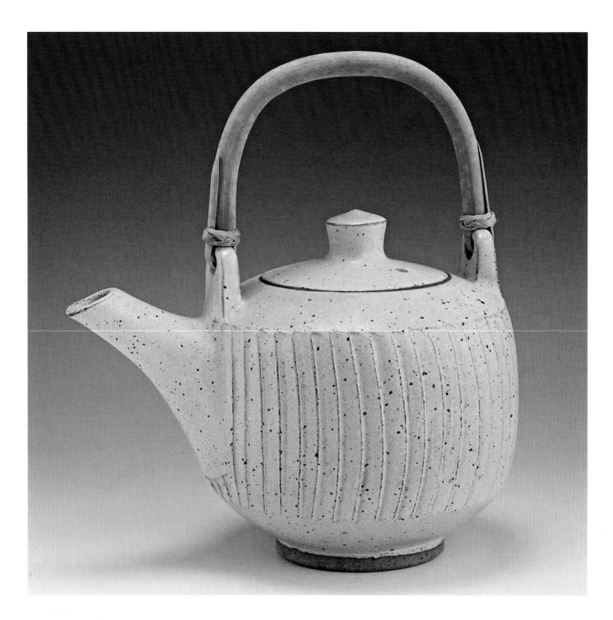

Teapot by David Leach,
ht: (excluding handle) 13 cm
(5 in). David Leach's fluting is
exceptional. Most of it was
done with a broken hacksaw
blade. *Photo by David Binch, by
kind permission of John Leach,
private collection.*

Previous page: Detail from
cup by John Maltby.

In his excellent, most useful and now historical book *Pottery in Britain
Today*, published in 1967, Mick Casson split pots into three categories:
wheel-thrown individual pieces, wheel-thrown repetition pieces and
handbuilt pieces. For the purposes of this book, I prefer to use two basic
categories, functional and non-functional. The main reason for this is purely
that many repetition pieces, such as David Leach's teapots, which in 1967
were seen as everyday, replaceable objects, have now been elevated to an
iconic level and cannot easily be separated from wheel-thrown individual
pieces. However, my own categories can be further subdivided, the lines
between them being rather ill-defined and often rather subjective,
particularly with regard to semi-functional objects.

Functional ceramics

Many people prefer to collect functional ware because it can be used in the home. Although I have many figurative and abstract pieces in my house, I prefer to centre my collection around functional pottery because I enjoy the experience and personal contact I feel when, for instance, drinking out of yunomi made by well-known potters. It is also useful to have vases that one can actually put flowers in, not just decorative 'vases' that would either fall over when flowers are inserted, or that cannot take flowers at all!

As I mentioned earlier, much repetition pottery, such as teapots and jugs, has become quite rare and thus elevated to the status of 'trophy' on account of its current resale value. These pots, although originally designed purely for use, are usually fine examples of the potter's art, so that if the owner no longer wishes to use them, they can enhance the decor of any home. David Attenborough provided a clear example for the increase in the value of functional ware on the BBC programme *Memento* in 1993. He described buying a Lucie Rie coffee set at the time of his marriage and using it until it became so chipped that he and his wife decided to replace it. He went to an auction and did manage to replace it, but for 'many, many times its original cost'. I hasten to add that the replacement coffee set was bought on the clear understanding that it would be used in the same way that the old one had been!

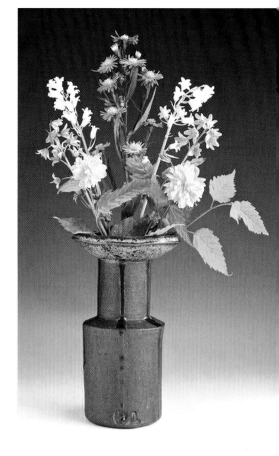

Above: Vase (with flowers) by Janet Leach, ht: 19 cm (7½ in). Stoneware. *Photo by David Binch, courtesy of the Crafts Study Centre, 2008, private collection.*

Left: Functional ware from St Ives Pottery. Porcelain with celadon glaze. Due to the apprentice system operated at St Ives, it is impossible to tell who made the majority of St Ives Pottery standard ware. *Photo by David Binch, by kind permission of John Leach, private collection.*

Vase by Poh Chap Yeap, ht: 25 cm (9¾ in). This vase, made from porcelain, is an almost exact copy of a Yuan dynasty (13–14th century) Chinese vase in the V&A Museum, London. *Photo by David Binch, private collection.*

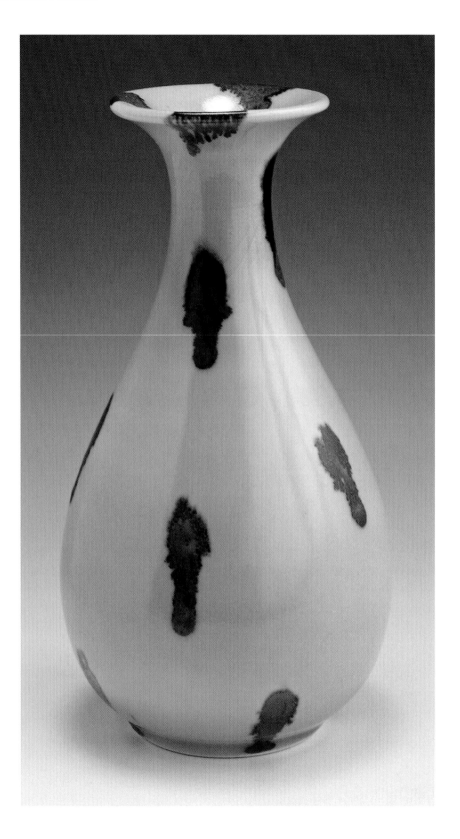

Some pots may be functional, but they were actually made purely to be enjoyed visually. An example of this is the Poh Chap Yeap vase illustrated here, which was inspired by a Yuan Dynasty Chinese vase. Although this bottle could be used for wine, water or oil, it would not be easy to use as the neck is quite narrow. It seems highly likely that it was made to be an ornament, and is far better employed as a decorative item.

Lucie Rie and Hans Coper made some exquisite examples of pots in this category. Hans Coper always wanted his pots to be described as pottery, not sculpture. He ensured that they would be regarded as such by making all of them containers. He called them 'these odd things I make'. Certainly, they were unusual and very imaginative in form. Very few of his pots were actually made to be used, and yet he had a strong affinity with function and became involved in the production of washbasins and facing tiles for buildings. However, the wonderful candlesticks he made for Coventry Cathedral and one or two other religious buildings were clearly made to be functional.

Of current potters, Kate Malone makes extravagant pots, particularly vases intended to be decorative but which are also functional.

Vessels that because of what they are would be described as 'functional objects', such as jugs or cups, but which if they were ever used would spill liquid everywhere, may be described as semi-functional or even abstract-functional. Good examples of these would be the jugs, vases and cups made by Elizabeth Fritsch and John Maltby, who, although influenced by very different sources, both deliberately produce more abstract vessels.

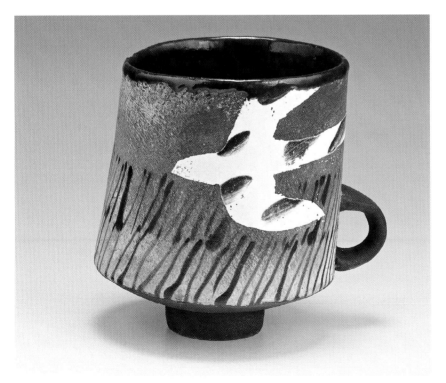

Stoneware cup with representational decoration, by John Maltby, ht: 10 cm (4 in). Maltby's designs are recognisable through his abstract English country scenes. *Photo by David Binch, by kind permission of the artist, private collection.*

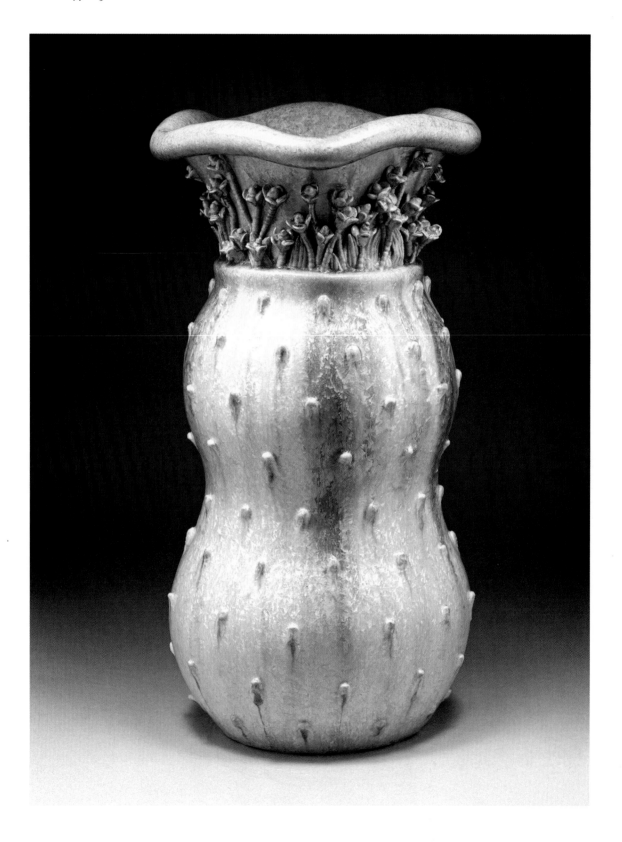

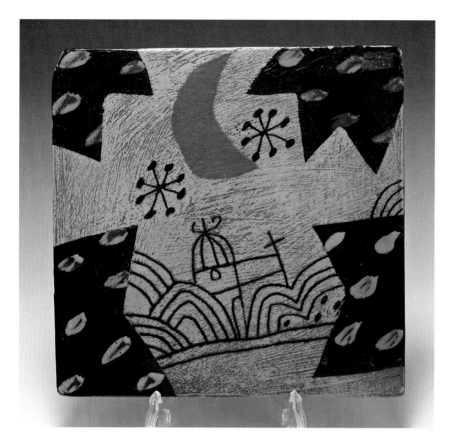

Opposite: Pippy Gourd Wearing a Succulent Necklace, by Kate Malone, ht: 40 cm (15¾ in). Kate Malone hand-coiled this piece and then modelled the surface details. It has a crystalline stoneware glaze. The necklace was inspired by succulent plants growing in Provence. *Photo by Stephen Brayne, courtesy of Adrian Sassoon Gallery.*

Left: Tile by John Maltby, size: 20 × 20 cm (8 × 8 in). *Photo by David Binch, by kind permission of the artist, private collection.*

Other examples of semi-functional ceramics are vases so large that they could never be used successfully for liquids or for flowers. Mick Casson made some enormous and beautiful jugs that could never be used successfully for pouring. Janet Leach made many pieces of very large proportions, as has David Roberts, who works in large-scale raku. In a rather fashionable London gallery I once noticed an exquisite David Roberts raku pot so large that it was being used as a waste bin!

Many potters have made tiles, which, although they could be used as an elaborate coaster for cups of hot coffee or teapots to stand on, are generally regarded as purely decorative and often have holes in the back to allow them to be hung on the wall. Among current British potters, Clive Bowen, Sarah Walton and John Maltby make excellent tiles. Bernard Leach made a huge number of small ones, many of which were installed as fireplace surrounds. He personally decorated and signed many of these picturesque tiles, and they are now highly sought after. Unfortunately, many of those that become available nowadays have the remnants of fixing cement on the back, which is very difficult to remove. Similar tiles were sometimes placed in wooden frames as teapot stands, and the wooden surrounds themselves are beautiful pieces of artisanship, often carried out by Dicon Nance, who became Leach's son-in-law.

Non-functional ceramics

One could subdivide the purely non-functional category into figurative and abstract forms which border on the sculptural, and pure ceramic sculptures.

Much figurative ceramic work comes far too close to the purely representational, and the most successful artists tend to try to capture the very essence of their subject matter. Currently, foremost amongst these makers are Emma Rodgers, Ian Gregory, Susan Halls, Philip Eglin, Christie Brown and Geoff Fuller. The Emma Rodgers cat illustrated here says everything about how a cat is, without trying to replicate exactly how a cat looks. The same can be said of Ian Gregory's dogs, which have all the attributes of dogs – personality, tenderness, clumsiness, strength – and are built with a true understanding of the structure of a dog's frame, without being an inert copy of a real dog.

An interview with Hal Higginbottom from the USA

Q. What drew you to collect studio pottery in the first place?
A. My wife and I began buying in the mid-1970s and frequently visited the Torpedo Factory in Alexandria, Virginia, a World War II 'torpedo factory' converted for use by local artists. One potter whom we especially admired was Solveig Cox. She made a lidded bowl for us (a 'casserole' in American English) that represents a 'chicken with an extra curly tail' as the handle on its lid. We still love it. In the mid-1980s, during occasional visits to Aspen, Colorado, we became familiar with a series of functional potters from that region and began to purchase occasional pieces. In the early 1990s, we began visiting the UK and made regular trips to mid-Wales, because of its extraordinary natural beauty. Having exhausted all the ruins and castles, one day my wife saw a brochure for Phil Rogers's Marston Pottery. The visit that followed became my introduction to 'studio pottery' and ultimately the turning point in my interest.

Q. Which potters do you most admire and why?
A. Hamada will inevitably be the first on the list. Bernard Leach follows; his writings, in our age of relativism, are not so easy to approach, but in the end what he cared about was a union of simplicity and trueness of form that was both elegant and spiritual. I still recall first seeing the Milner-White example of the Leaping Salmon bottle and just being awestruck by it. Warren MacKenzie, like Bernard Leach, has had an enormous impact, as both teacher and potter, on entire generations of American potters. Byron Temple, whose work I have only recently come to know.

Q. What criteria do you use when selecting which pots to buy?
A. Sadly, a bought pot must be an affordable pot, although at various times even that concept seems relative. Once that test is met, the real criteria become whether the piece looks right to the eye and feels right in the hand. In a room of many pots, something about one particular pot will set it off from the other pots, and the decision is never very hard.

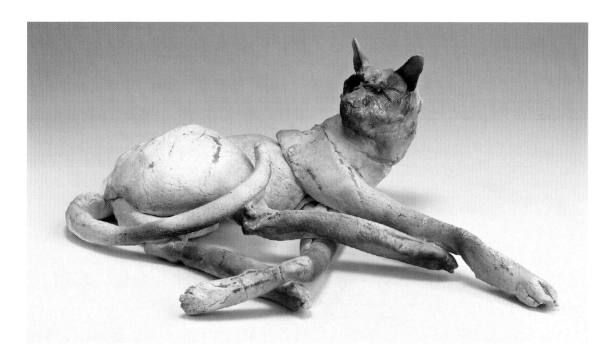

Cat made from mixed clays, by Emma Rodgers, l: 28 cm (11 in). *Photo by David Binch, by kind permission of the artist, private collection.*

Q. Of current potters, whose work do you think will be the antiques of the future?
A. *My list, across cultures and in no particular order, would include Richard Batterham, Brother Thomas, Phil Rogers, Rob Barnard, Warren MacKenzie, Bill Marshall, Jim Malone, Clive Bowen, Mike Dodd, Mark Hewitt, Ray Finch, Walter Keeler, Tatsuzo Shimaoka and Ken Matsuzaki.*

Q. Which little-known potters would you recommend people investigate?
A. *I would recommend Mary Law, Blair Meerfeld, Mark Shapiro, Robert Briscoe, Sandy Simon and Wayne Branum in the United States, and Kevin de Choisy, Lisa Hammond, Nick Rees and Gary Wood in the UK. Each potter is well regarded by fellow potters, and each has evolved a compelling personal style worthy of exploration and collection.*

Q. Which pots would you consider iconic studio pots?
A. *I will mention only five:*
The Bernard Leach Leaping Salmon bottle now in the Milner-White Collection of the York City Art Gallery. It was and remains the most iconic image for me from studio pottery of this tradition.
A Hamada 'trailed loop' decorated bowl, plate or bottle.
A Byron Temple 'secret jar'.
A Warren MacKenzie lidded box, in either square or pentagonal form, typically with shino glaze.
A Hamada rectangular bottle with sugarcane design, c.1960, owned by the Metropolitan Museum of Art in New York.

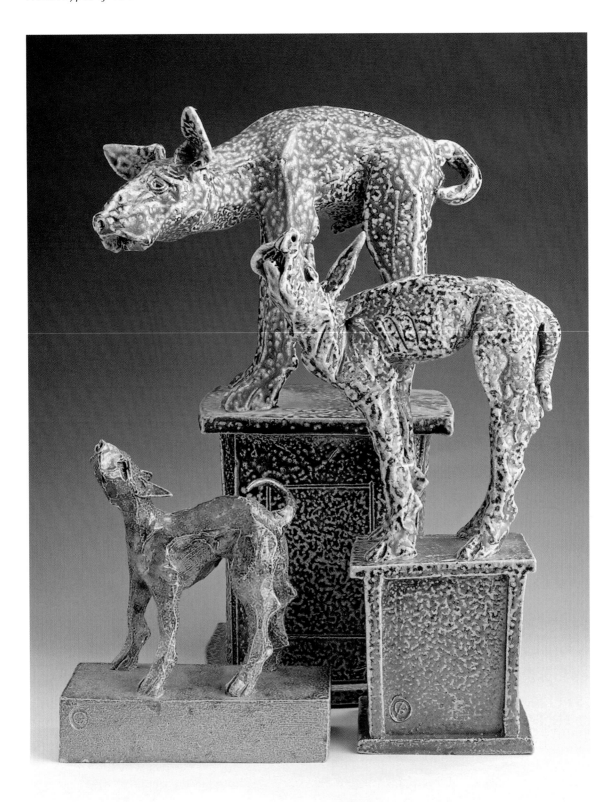

Opposite: Dogs made in salt-glazed stoneware, by Ian Gregory. Ht: (largest) 38 cm (15 in), (middle) 30 cm (11¾ in), (smallest) 19 cm (7½ in). *Photo by David Binch, image by kind permission of the artist, private collection.*

Left: Vessel for Dark Air II, large sculptural form by Gordon Baldwin. Ht: 60 cm (24 in). *Photo by Philip Sayer, courtesy of Barrett Marsden Gallery.*

Purely abstract ceramics are really sculptures using clay as a medium, though the prices of these objects rarely reflect the level of skill and imagination involved. It is not often that work by Gordon Baldwin or Martin Smith, for example, comes up for sale, but if it does, it can often be bought at a fairly reasonable price. In 2001, a superbly crafted, fascinating abstract form by Martin Smith realised £2,700 at auction in London. More recently, in May 2006, a Gordon Baldwin sculpture realised £1,320, while in the same sale a semi-functional vase by Elizabeth Fritsch made £9,120, a Lucie Rie vase made £13,200 and a Hans Coper 'spade form' vase made £18,000! If you can find items by Baldwin or Smith, it would almost certainly be worth buying them, as I feel they are bound to gain in value. Another potter whose sculptural forms are likely to increase in value is Ewen Henderson. These can still be bought relatively cheaply.

Collecting to a Theme

As I mentioned earlier on, one way to avoid becoming too obsessed with collecting every kind of pot going is to restrict oneself to a theme or two. This particularly applies if one is short of space. Choosing a theme and assembling groups of related pots can be very satisfying, practicable and aesthetically very pleasing. The pots bought will complement each other, perhaps forming groups that relate the history of a movement or genre, or illustrate the variation possible in one particular firing technique – salt glazing, for example. A collection that revolves around one particular form is another option. Tea bowls, teapots or perhaps vases are good examples of forms that have become the object of a particular collector's eye.

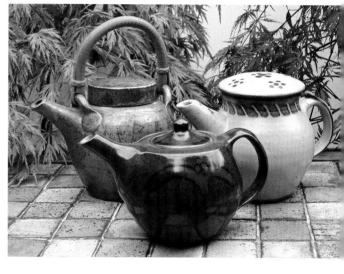

Above: Teapots by Sarah Walton, ht (excluding handle): 14 cm (5½ in), Bernard Leach, 14 cm (5½ in), and Geoffrey Whiting, 12 cm (4¾ in). *Photo by Alistair Hawtin.*

Opposite: Teapot by Sarah Walton, ht: 14 cm (5½ in). Salt-glazed stoneware. *Photo by David Binch, by kind permission of the artist.*

It is certainly true that one of the most popular themes chosen by collectors in recent years has been the tea bowl in its various guises. Collectors regard the yunomi in particular as a pot that encapsulates the style of a potter in a small, easily displayed, personable, usable and often inexpensive form.

Tea bowls are quite simply cups without handles, and fall into two categories: yunomi and chawan. These names are Japanese, but are used by potters and collectors worldwide. The yunomi is much smaller than the chawan and has humbler origins. The chawan is usually about the size of a small cereal bowl and has its origins in the Japanese tea ceremony. To

Stoneware chawan, tenmoku
with nuka rim and finger-
wipe decoration, by Shoji
Hamada, dia: 15.5 cm (6 in).
*Photo by David Binch, by kind
permission of Tomoo Hamada,
private collection.*

Previous page: Detail from bud
vase by David Leach (*see
opposite*). *Photo by David
Binch, by kind permission of
John Leach.*

Yunomi by Shoji Hamada,
ht: 9 cm (3½ in). *Photo by
David Binch, by kind permission
of Tomoo Hamada, private
collection.*

understand more about its proper use, and the conventions a chawan should adhere to in order to satisfy the aesthetic and practical demands of the Japanese tea master, one needs to read about the tea ceremony; several good books on the subject are included in the bibliography at the end of this book. Chawan are a convenient size to collect and are used in the West for many purposes, if not often for tea.

The yunomi is a much humbler pot, usually about the size of a small household mug without the handle. It also has Japanese origins but has no direct connection with the tea ceremony. It often has a turned foot, making it easy to use for tea, coffee or wine drinking, with the thumb on the rim and two fingers on the foot. The chawan and the yunomi are both attractive, tactile and functional forms, and ideal for collecting, as they are made by many potters in both East and West.

Another popular theme among collectors is small, lidded jars. Once again, these are very functional and, because of their size, very practical to collect. Lidded preserve pots or sugar bowls can make a most attractive group, as can bud vases, another popular form with collectors. Bud vases are small, usually very attractive in shape, and easy to display. Above all, they are functional, and as you will have already gathered, functionality is a very important aspect of my own collection.

Although it is easy enough to find good examples that follow a theme in exhibitions by individual potters and in galleries, there are occasionally specialist themed exhibitions. The idea of selling through themed exhibitions has been around for a long time. The Craft Potters' Association used to hold exhibitions in the 1970s where a particular focus was chosen. From time to time, they still represent potters' work in a similar way. In

Bud vases, various glazes. Collectors may spot vases by Bernard Leach, Katharine Pleydell-Bouverie and David Leach amongst this group. *Photo by David Binch.*

1997, the Oakwood Gallery near Mansfield in Nottinghamshire, England held an exhibition entitled 'Totally Tea Bowls', where sixteen noted potters were asked to contribute between 10 and 15 tea bowls each. As well as being an extremely successful event, it was also great fun. Many potters who had not thought of the tea bowl as a medium of expression joined with those who regularly made both chawan and yunomi to put on a colourful and diverse show. One of the great advantages of such a show is the chance to compare like for like and through this process to refine one's taste. The makers came from many countries, including Japan, the USA, France, New Zealand and the UK.

Tea bowls displayed in CD racks at 'Totally Tea Bowls'. Note the diversity of forms, colours and textures. *Photo by Alistair Hawtin.*

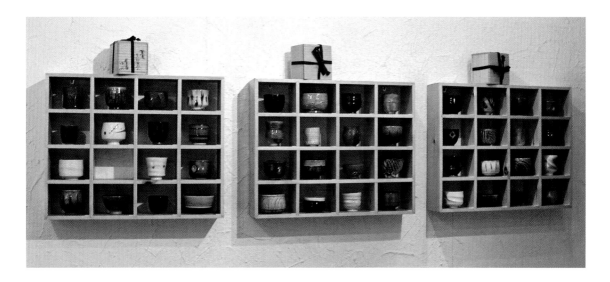

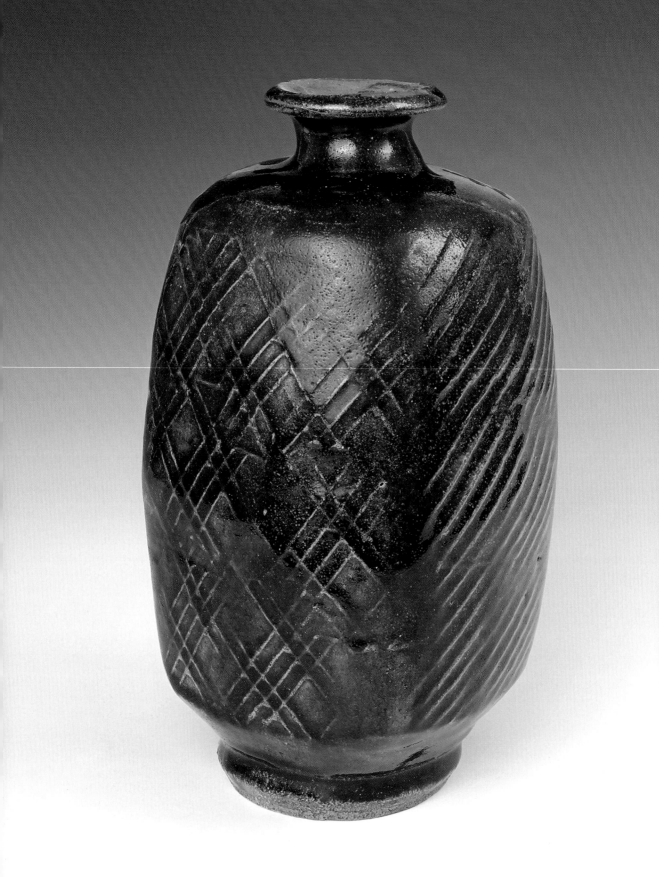

Who Are the Makers?

I have chosen a few representative potters to write a bit more about, makers whose work I feel is particularly interesting. Some are alive, some no longer with us. Unless otherwise stated, they are British.

BERNARD LEACH

Bernard Leach, born in Hong Kong in 1887, is generally recognized as being the father of British studio pottery. He came to England in 1897 and studied drawing and etching in London. He returned to the Far East in 1909 to teach in Japan, met the potter and artist Kenkichi Tomimoto, and was introduced to the making of raku ceramics. He also met Soetsu Yanagi and Ogata Kenzan VI. Shortly after the revelatory experience of raku, he began making

Left: Tenmoku lidded jar by Bernard Leach (right), ht: 23 cm (9 in), with late 18th-century Korean honey jar by unknown potter, ht: 24 cm (9½ in). *Photo by David Binch, by kind permission of John Leach, private collection.*

Opposite: Shoji Hamada bottle, ht: 27 cm (10¾ in). Dark ash glaze and pattern created using a paddle. *Photo by Phil Rogers, by permission of Tomoo Hamada, private collection.*

A group of pots by Bernard Leach. Kiln damage and a gold lacquer repair can be clearly seen on the fluted celadon bowl. *Photo by David Binch, by kind permission of John Leach.*

Previous page, top: Detail from chawan by Mike Dodd (see p.80).

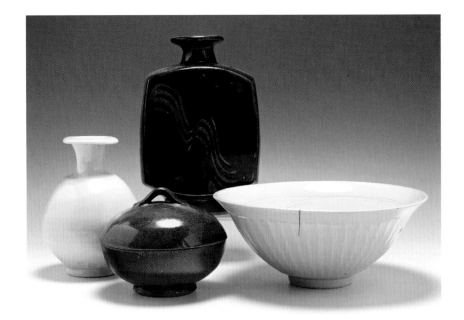

pots seriously. In 1919 he met Shoji Hamada, and in 1920 they travelled to England to establish the Leach Pottery in St Ives.

Leach had very strong views on the aesthetics of pottery making, and he never stopped experimenting with glazes, clays and designs. His ideas on form in particular were based largely on Chinese and Korean pots, except for his jugs, which were based on English medieval examples. Through these influences, he was responsible for beginning what has come to be known as the Anglo-Oriental tradition of British contemporary pottery. Although his pots show clear influence of the source ceramics, they are most certainly not copies. Michael Cardew described Leach's attitude towards pottery very clearly: 'It was not a question of trying to imitate the forms of Chinese or Korean pots. It was a perception about the idea or attitude which lay behind them.' (Cardew quoted by Peter Fuller in his book, *Images of God – The Consolations of Lost Illusions*, 1985).

Leach died in 1979, but his influence lives on.

SHOJI HAMADA (JAPAN)

Hamada was born in Tokyo in 1894. He had a good understanding of chemistry and studied glazes at the Kyoto Ceramics Research Institute in Japan. He met Bernard Leach and travelled to England with him to start the Leach Pottery. Without Hamada's support and advice, particularly in the area of glaze technology, the pottery would have struggled even more than it did. Although he only lived in England for four years, his influence on the development of contemporary ceramics in the West was extremely significant.

Returning to Japan, he established his pottery in Mashiko, where he continued to make pots in the Mingei style. In 1955, he was made a Living

National Treasure, the highest accolade that can be bestowed on a craftsperson in Japan; very few receive it. Hamada's pots are much admired by many connoisseurs of ceramics for their strong forms and loosely thrown style, in contrast to the more structured, forms of Bernard Leach, for example. He only signed his work during the period he was working at the Leach Pottery, as he believed that his pots ought to be recognizable simply by their style, and that craftspeople should be 'unknown'. He did, however, sign the boxes in which his pots were sold.

It can be argued that Hamada, along with Leach, was the most influential potter of the 20th century in terms of the development of contemporary ceramics around the world. He died in 1978.

Curved bottle by Hamada. Stoneware with ash glaze and enamel decoration, ht: 24 cm (9½ in). *Photo by Phil Rogers, by kind permission of Tomoo Hamada, private collection.*

Bowl with brushwork design, by Bill Marshall, dia: 19½ cm (7¾ in). This has a pale blue celadon glaze over a porcelain body. *Photo by David Binch, by kind permission of Marjorie Marshall, private collection.*

BILL MARSHALL

William Marshall, known as Bill, was the first apprentice taken on at the Leach Pottery. He was born in St Ives in 1923 and joined the pottery straight from school in 1938, as a 14-year-old. Apart from a few years of national service, he potted all his working life, spending 44 years at the Leach Pottery. Marshall had a close working relationship with Bernard Leach, and under his instruction developed into one of the best throwers in the country. He was actually responsible for throwing a large number of Leach's large pots in later years. When Bernard Leach died, he decided to set up his own pottery at Lelant, a small community just outside St Ives. He died in May 2007.

Bill Marshall was a remarkable man. For someone with relatively little schooling he developed a consummate understanding of oriental pottery and an intuitive feel for quality work in many fields. His own work carries an unmistakable style in form and decoration, which is admirable for someone who for so many years worked so close to the hot flame that was Bernard Leach. Marshall was incredibly generous with his time for those passionate about pots and always showed an almost childlike enthusiasm for the best examples in any craft, but particularly pottery, that fulfilled his aesthetic criteria. In his last few years, his output was limited, as he preferred to follow his many other pursuits. He never ceased to be grateful for the support and instruction Bernard Leach gave him, and I never heard Bill say a bad word about 'Mr Leach'. His work was influenced by Korean and Chinese pots.

MICHAEL CARDEW

Michael Cardew arrived at the Leach Pottery in 1923 and, after virtually demanding to be taken on, became its first student. He was born in Surrey in 1901. He had an academic background, having studied Classics at Exeter College, Oxford, but having been taught to throw by William Fishley Holland, he became captivated by the making of pottery. Although he learnt much from Bernard Leach, he always claimed to have been influenced more

Left: Cider flagon by Michael Cardew, ht: 56 cm (22 in). Earthenware with slip decoration. *Photo by Phil Rogers, by kind permission of Seth Cardew, private collection.*

Above: The bottle kiln at Winchcombe Pottery. *Photo by Alistair Hawtin.*

by Hamada. Strangely enough, though, his real passion was English slipware, and in 1926 he took over a pottery at Winchcombe near Gloucester, England. With the help of Elijah Comfort, who had previously been its chief thrower, and a young lad called Sidney Tustin, Cardew reopened the pottery, making earthenware and nothing else. Now owned and run by Ray Finch, Winchcombe Pottery is still open to this day. The original bottle kiln used by Cardew is still standing, and the pottery remains committed to the making of serviceable, functional or, as Ray Finch prefers to call it, usable pottery.

Cardew moved on to Wenford Bridge in Cornwall in 1939, and there produced mainly stoneware. He spent much of the next two decades travelling between England and Africa, where he set up potteries run mainly by local people at Abuja in Nigeria and Vume Dugame in Ghana. It was in Abuja that he discovered Ladi Kwali, a local woman already making impressive handbuilt

pots at the time Cardew was setting up the pottery. She quickly learned to throw on the wheel, and developed an international reputation after her pots were shown at the Berkeley Gallery, London in 1958, 1959 and 1962. On returning to Wenford Bridge in 1965, Cardew began his seminal book *Pioneer Pottery*, which was published in 1969. Despite having officially retired, he continued to lecture all over the world, and exerted an enormous influence upon potters throughout the West, particularly in the USA. Michael Cardew died in Cornwall in 1983.

KENNETH QUICK

The somewhat tragic story of Kenneth Quick created a certain mystique that surrounds his pots even today. He was born in 1931 and at the age of 14 was taken on as an apprentice at the Leach Pottery. He was regarded by Leach as a talented pupil who would go on to have an illustrious career. Although clearly displaying the influence of Hamada, he produced pots of a distinctive style and quality. He ran his own pottery at Tregenna Hill in St Ives for five years from 1955, but returned to the Leach studio in 1960. Sadly, he was only to live a few more years: in 1963, on a visit to Hamada in Japan, he was drowned in a swimming accident.

Despite Quick's short life, his pots display a mature and confident skill, and are now highly sought-after. You can see why from the quality of the yunomi illustrated here.

Yunomi with brushwork decoration, by Kenneth Quick, ht: 9 cm (3½ in). *Photo by David Binch, by kind permission of the artist's estate, private collection.*

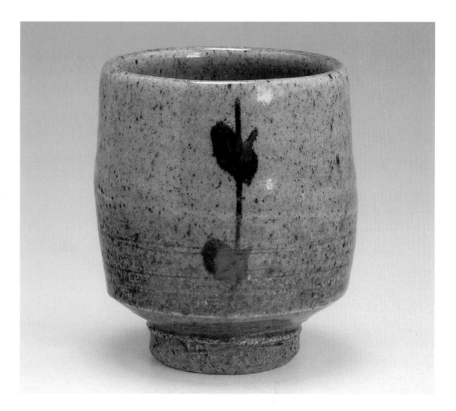

JANET LEACH (USA)

Although Janet Leach is sometimes accused of destroying the workshop system at the Leach Pottery, she was a remarkable woman and a potter with a unique style. Clearly, she was not always easy to work with, but many hold the view that the old apprentice system had outlived its usefulness and the Leach Pottery needed a change. Despite her closeness to both Bernard Leach and Hamada, her pots are easily recognized for their strong (and often large) forms and Japanese influences. Although her pots are quite unlike Bernard's, she shared with him a desire to make ceramics that held the spirit of the source vessels without being copies.

During the Second World War Janet had worked in shipbuilding as a welder on destroyers, and she only turned to pottery in 1947. She first met Bernard when he visited the USA in 1952. In 1954, she persuaded

Small bottle by Janet Leach, ht: 17 cm (6¾ in). Black clay with white decoration. *Photo by David Binch, courtesy of the Crafts Study Centre, 2008, private collection.*

Hamada to take her over to Japan for two years. She worked at Hamada's pottery in Mashiko for six months, but it was in the mountain village of Tamba that she found a lasting spiritual influence. Both experiences helped develop her unique style. Before her death in 1997, on a visit to the Leach Pottery I bought a small vase made of black clay; despite its relatively small size (16.5 cm/6¹/₂ in), if placed with other pots it tends to dominate the group. Sadly, in the last few years of her life, spirits of another kind took their toll upon her health and she made fewer pots. I have fond memories of my visits to her and was delighted to be able to buy some battered pots from her own (and therefore Bernard's) collection in an auction held after her death; I use them frequently.

HANS COPER

Hans Coper came to England in 1939 from Germany, where he was born in 1920. In 1946 he met Lucie Rie and began working with her at her Albion Mews studio in London. His first one-man show was held at Henry Rothschild's Primavera Gallery in 1958, the year in which he left Rie's studio to set up his own pottery in Hertfordshire. His work, like Rie's, was very different from Leach's Anglo-Oriental style. Coper taught at Camberwell School of Arts and Crafts and at the Royal College of Art, and although not renowned for his lecturing he had a significant, if arguably short-lived, effect on the development of studio pottery. Sadly, he suffered from a debilitating disease which made working very painful, and he died at a relatively young age, in 1981, at his home in Somerset.

Stem cup by Hans Coper, ht: 10 cm (4 in). Stoneware with brown and white slips. *Photo by David Binch, by kind permission of the artist's estate, private collection.*

Hans Coper's work has an obvious sculptural quality, although if you look inside many of his forms, you will find an internal cylinder for flowers, showing that his pieces were made as vessels. His pots are considered beautiful for their marriage of pure form and austere surface quality, and have become immensely valuable. A lucky and perceptive student discovered one of his pots at a car-boot sale and subsequently sold it for a fortune. Another of his vessels made the news when a school in Somerset sold it at auction. It had been exchanged with the school for a goat from the school's farm! To see the best collection of his and Rie's work, visit the Sainsbury Collection at the University of East Anglia.

Yellow bowl, Lucie Rie, dia: 18 cm (7 in). *Photo by David Binch, by kind permission of the artist's estate, private collection.*

LUCIE RIE

Lucie Rie had already worked as a potter in her native Vienna before coming to England in 1938. She was born Lucie Gomperz in Vienna in 1902, and after working for an Austrian ceramics manufacturer, she set up her own studio in 1925. She had already won a medal at the Paris International Exhibition in 1937 before she fled the Nazis and settled in Albion Mews in London. After the war, she opened a pottery and button-making workshop. She was joined in 1946 by Hans Coper, who became a partner in the pottery and worked with her until 1958. They continued to be great friends until Coper's death.

Rie taught at the Camberwell School of Arts and Crafts from 1960 to 1971, and in 1969 received an honorary doctorate from the Royal College of Art. She was awarded the OBE in 1968 and the CBE in 1981, and was made a Dame in 1991, a year after she had ceased making pottery following a series of strokes. She died in 1995, aged 93.

JAMES WALFORD

James Walford, in my opinion, is one of the unsung heroes of studio pottery in Britain. He was born in 1913 and studied painting at the Slade School of Art and at the Royal College of Art, but his growing love of pottery culminated in 1945 in a change of discipline. He established a pottery in Surrey, where he worked from 1948 to 1959. He then moved to Crowborough and stopped potting until about 1977, when he resumed on a very small scale. He was a wealthy man and pursued ceramics almost as a hobby, but still produced some beautiful and spectacular effects with glazes on good, solid forms.

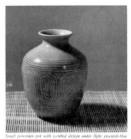

Advert for James Walford in *Pottery Quarterly*. Photo by Phil Rogers.

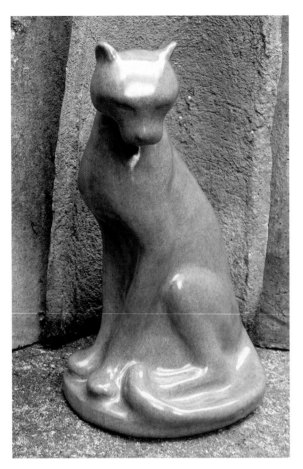

Puma, by James Walford, ht: 24.5 cm (9¾ in). Green celadon glaze over a stoneware body. *Photo by Alistair Hawtin, private collection.*

In the early days Walford advertised his own wares and sold them through the auction houses. In terms of self-promotion, he was years ahead of his time, and many modern-day potters could learn a lot from the strategies he employed. I visited him and his wife in Crowborough and was amazed at the most incredible ceramics – both pots and sculptures – that filled the house. Many were original pieces from the Chinese Tang and Sung dynasties, but a number had been made by him and were startlingly good. On the landing was a Tang horse, and the plate I ate my cake off was a Sung celadon; at least that was the first impression I had. On closer inspection both had 'JW' stamped on the bottom! On one occasion, I took him a gift of one of my modest yunomi. His wife, who I think was Russian, seized it enthusiastically. 'But find zomething for Mr Hawtin, Chames!' she exclaimed. To my surprise, he exchanged my pot for the most stunning sculptural puma in a green celadon glaze.

Walford died in 2001, and I was fortunate enough to have the chance to buy some items from the auction of his effects. Included in this auction was the yunomi I had given him, though I was unable to buy it back.

Walford was fascinated by oriental glazes, particularly Sung-dynasty celadons and early Chinese ash glazes. Many of the ceramics in his house were *almost* indistinguishable from the originals, and yet they had a special quality that made them distinctly his.

KATHARINE PLEYDELL-BOUVERIE

Katharine Pleydell-Bouverie was born in 1895 and was one of the few women amongst the early pioneers of British studio pottery. She learned pottery at the Central School of Arts and Crafts and then in 1924 persuaded Bernard Leach to take her on for a year at the Leach Pottery. They became close friends and, although she sometimes referred to him by the nickname 'Rik', when writing to him she frequently called him 'Maître' (master/teacher).

Pleydell-Bouverie was descended from a landed aristocratic family, and in 1925 she built a wood-fired kiln and workshop on the family estate at Coleshill House in Berkshire. For her entire working life, she experimented with ash glazes made from the plants and fallen wood on the estate. With her large 'murderer's' hands (her description) she made pots like pebbles or small boulders. All her ceramics have a wonderful tactile quality and a quiet

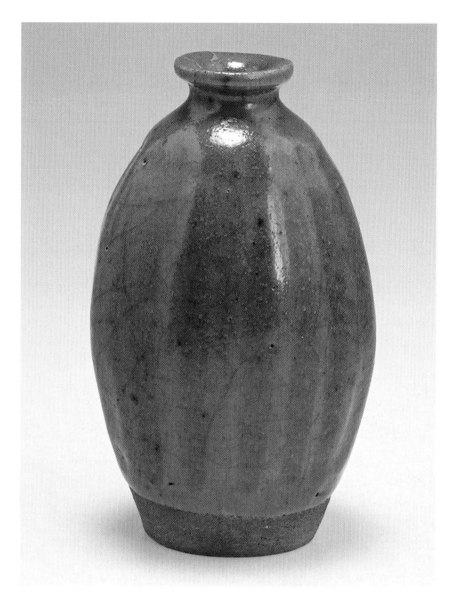

Bottle, Katharine Pleydell-Bouverie, ht: 10 cm (4 in). Ash-glaze master Phil Rogers has said of this pot that 'the glaze is a deep sea green with a satisfying oily quality ... This is Pleydell-Bouverie at her very best.' *Photo by David Binch, private collection.*

strength that influenced many potters of the late 1950s and 1960s, including Richard Batterham, upon whom they had a deep and lasting effect. Pleydell-Bouverie kept meticulous records of her experiments with ash, and if you look closely at the foot of most of her pots, you will find a code in roman numerals, which relates to these records. Her working notebooks are housed at the Craft Study Centre in Farnham, Surrey, England.

In 1946, she moved to Kilmington Manor, where she continued to work until her death in 1985. In time she stopped wood-firing and switched to an electric kiln, and yet the pots retained a wonderful soft and often jade-like quality, unlike anything I have seen on other electric-fired pots.

Chawan by Ewen Henderson, dia: 15½ cm (6 in). Mixed clays and stains. Henderson described this to me as 'the best teabowl I have ever made'. *Photo by David Binch, by kind permission of the artist's estate, private collection.*

EWEN HENDERSON

Ewen Henderson's pots are something of an acquired taste, but they are also technically fascinating and unique. His speciality was to create a surface to work on with one type of clay, then to add stains and oxides to other types of clay, such as paper clay, and apply them to the original surface. The created surfaces are usually rugged and subtly coloured. Different types of clay that really should not blend are somehow brought together, often after more than one firing, to create a most interesting object.

Henderson was born in 1934 in Staffordshire, England and was 29 before he finally enrolled at Goldsmith's College. There, although initially interested in drawing and painting, he encountered clay as a medium and fell in love with it. After a year, he undertook a course at Camberwell School of Arts and Crafts, where he was taught by both Rie and Coper. The work he produced there was very sculptural, and in 1970 he joined the staff at the school.

Henderson always believed in the importance of sketching, and in about 1990 he began drawing megaliths, which he felt had a profound effect on his work. Just before he died in 2000, he was awarded an honorary fellowship of the London Institute, in recognition of his contribution to art and of his 30 years' distinguished teaching at Camberwell. A number of successful ceramicists, among them Jim Malone and Angus Suttie, were students of Henderson.

MIKE DODD

Opposite: Bottle by Mike Dodd, ht: 28 cm (11 in). Stoneware with a tenmoku glaze developed by Mike Dodd himself, and finger-wipe decoration. *Photo by David Binch, by kind permission of the artist, private collection.*

Mike Dodd was born in Surrey in 1943. At Bryanston School in Dorset, he was taught pottery by Donald Potter, a most influential teacher and a gifted artist in his own right. He studied medicine at Cambridge University and left in 1965 with an honours degree. But by this time, he was already fascinated by ceramics, and enrolled in a postgraduate course in the

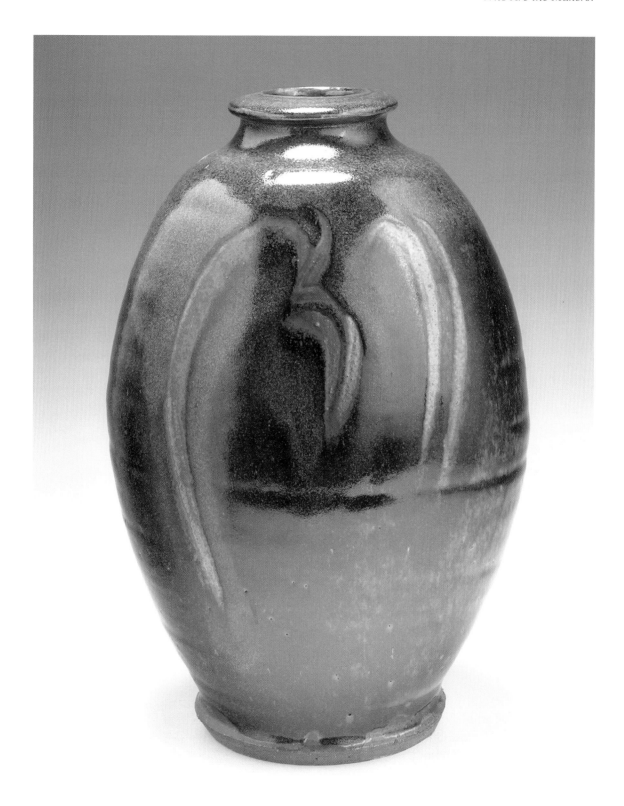

Chawan by Mike Dodd, dia: 13½ cm (5¼ in). Bill Ismay coveted this chawan but was unable to buy it at a CPA (Contemporary Potters Association) exhibition. *Photo by David Binch, by kind permission of the artist, private collection.*

discipline at Hammersmith College of Art, in London. Since then he has had five kilns in various parts of England, and has also worked in Peru. In 1981, he was appointed to the position of Senior Lecturer at Cumbria College of Art in Carlisle, where he eventually became Department Head, working for some of the time with Jim Malone.

Mike Dodd's biggest interest is making glazes from the raw materials around him. Cumbria was a particularly good area for this pursuit, being rich in granites and irons. After a very fruitful time there Mike returned south in 1994, and since then has held many teaching positions.

He is a master of his particular range of glazes, and the results of these can be stunning. His current pottery is in Butleigh, Somerset. The setting is idyllic and many would argue that he is producing his best-ever work, engaging in a healthy work/life mix of pottery with gardening and golf! Mike is a man of integrity and deep personal values, and his commitment to minority causes is admirable.

JIM MALONE

Jim Malone was born in Sheffield, England in 1946. He trained as a teacher, and then gained a first-class honours degree in ceramics at Camberwell in London. Another part of his training was to spend a summer at the Winchcombe Pottery with Ray Finch.

Chawan by Jim Malone, dia: 12 cm (4¾ in). Tenmoku glaze. Bought by the author from Ainstable when the potter was moving workshops. It was in use by Jim Malone up to the time of purchase and still contains tea leaves! *Photo by Alistair Hawtin, by kind permission of the artist', private collection.*

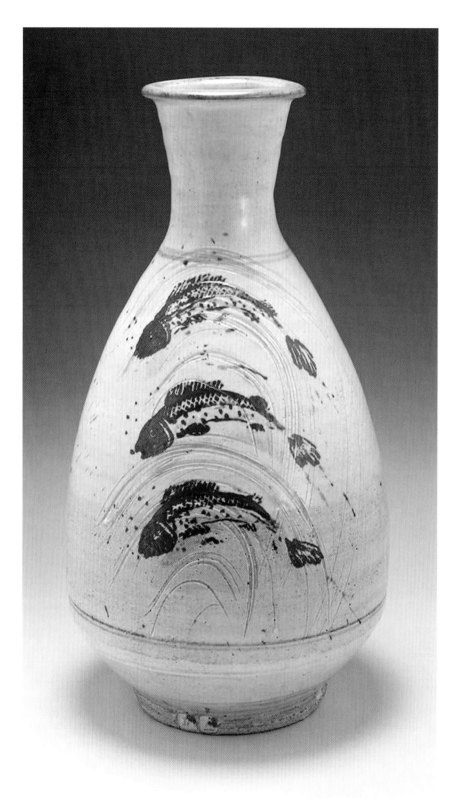

Fish bottle by Jim Malone, ht: 32 cm (12½ in). Stoneware with white slip and brushwork decoration under a clear glaze. *Photo by David Binch, by kind permission of the artist, private collection.*

After completing his course, he opened a pottery at Llandegla near Wrexham in North Wales. He stayed there for six years before taking on an artist-in-residence post at Cardiff College of Art in 1980. In 1982, he moved to Cumbria to work with Mike Dodd at the Cumbria College of Art, and set up a pottery in the nearby village of Ainstable. For a while, his and Mike Dodd's careers and pot-making followed similar paths, and some say that it was quite difficult to tell the difference between much of their work. Jim's influences are many, amongst them the Korean pottery of the Yi or Choson dynasty and Chinese pottery.

During his time in Cumbria, Jim Malone's work matured considerably and developed its own distinctive style. Towards the end of his time at Ainstable, he produced some of the most remarkable tenmoku glazes and almost satin-like clear glazes, which are most effective over white slip. One of these bottles is shown on p.2.

Jim Malone has never compromised by veering from what he believes in. He is one of the most highly respected craftspeople in Britain. When he closed the pottery at Ainstable, Jim had a big sale of many of the pots that remained at the pottery. I managed to persuade him to part with the self-made chawan he was drinking from during the sale; I treasure it.

KATE MALONE

Kate Malone makes pots that are colourful, energetic and full of life, reflecting her personality! She was born in London in 1959, and after graduating from Bristol Polytechnic and the Royal College of Art, she set up a studio in London. She now also has a studio in rural France. Her main interest is organic forms, and her tactile and often large work, such as

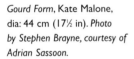

Gourd Form, Kate Malone, dia: 44 cm (17½ in). *Photo by Stephen Brayne, courtesy of Adrian Sassoon.*

gourds, pumpkins and pineapples, is strongly sculptural. Her pots take the forms of vessels, and although her work looks as if it should function, it is predominantly decorative. She works with T-material clay, which is more often associated with industrial ceramics; it is a very clean white clay and, as a result, the glazes she produces are very bright. Her basic forms, which usually begin as coiled pieces, are then 'dressed', as she describes them, 'like people wearing different coats'. Her enthusiasm and energy are expressed in the boldness of her work and her description of opening a kiln being 'like unwrapping a present'!

KANG HYO LEE (SOUTH KOREA)

Kang Hyo Lee lives and works in South Korea, although he has visited both England and the USA to demonstrate his skill. He studied ceramics at the College of Fine Arts at Hongik University in South Korea, and after completing his degree went to work in the traditional Korean style of Onggi ware. Although Onggi pots can be quite modest in size, they can also be huge – big enough to hide a man – and are made of a red clay frequently decorated with vigorous and spontaneous finger-wipes. Kang Hyo's pots can be hugely spectacular, but his chawan are superb! There is a fine example of his large work in the Victoria and Albert Museum in London. In 2003, I was lucky enough to visit Kang Hyo, and watched him at work (see photos). His decoration is tremendously energetic, and uses either finger-wipes or brushstrokes on white slip over a dark clay body, in the Punch'ong tradition of Korean pottery. His pots are stunning examples of contemporary Korean pottery at its best.

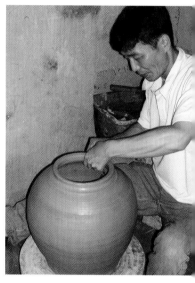

Above: Kang Hyo Lee at work. *Photo by Alistair Hawtin.*

Left: Kang Hyo, large storage pots in the Onggi tradition. The largest jar is over 1 m (39½ in) tall. *Photo by Alistair Hawtin, by kind permission of the artist.*

Traditional Onggi pots with finger-wipe designs, resembling fireworks, by unknown makers, ht (approx.): 50 cm (19 ¾ in). *Photo by Alistair Hawtin.*

SUNG JAE CHOI (SOUTH KOREA)

Choi works in the Korean Punch'ong tradition in a similar way to Kang Hyo Lee. He feels that the beauty of ceramics comes naturally through the processes involved in working with clay and fire. He uses white slip over the clay body and then either paints on a design or incises a decoration through the slip. As brushes he tends to use objects such as twigs, bamboo, millet sprigs or fingers. His simple forms, many of which are press-moulded, are the ideal canvas for his bold, natural and expressive paintings in clay. He studied ceramics at Hongik University and is currently a professor at the Korean National University of Cultural Heritage. His works are included in the collections of many museums, including the V&A in London, and I am sure they will become much more familiar to us in the coming years.

TATSUZO SHIMAOKA (JAPAN)

Shimaoka was Hamada's most successful pupil, and became a Living National Treasure, like his mentor, in 1996. He was born in Tokyo in 1919, and graduated from the Tokyo Institute of Technology. He studied pottery under Hamada from 1946 to 1949, and set up his own studio adjacent to Hamada in 1953. His father was a rope-maker, and Shimaoka's trademark designs incorporated impressed rope patterns, which many have tried to imitate. He travelled and exhibited all over the world, including in Liberty's in London. Sadly, Shimaoka died in November 2007.

KEN MATSUZAKI (JAPAN)

On my visit to Japan in 2003, I visited Matsuzaki and was staggered at the quality and range of his work. He was born in Tokyo and received a degree in Ceramic Art from Tamagawa University School of Fine Arts in Tokyo. He moved to Mashiko in 1972 to work as an apprentice to Tatsuzo Shimaoka.

Above: Moon Flask by Ken Matsuzaki, ht: 29 cm (11½ in). Stoneware with feldspathic shino glaze. *Photo by David Binch, private collection.*

Left: Cut-sided bottle and yunomi in Oribe style by Ken Matsuzaki, and yunomi with rope pattern by Tatsuzo Shimaoka. *Photo by David Binch.*

After a five-year apprenticeship, he established his own kiln just down the road from Shimaoka. His cut-sided bottles are very powerful forms, particularly those fired in the firebox of the kiln (yohen style). He has many styles and uses many glazes, including Shino, to great effect. Like Kang Hyo and Sung Jae, he is definitely a potter of high quality, whose work, I predict, will become more familiar to collectors over time.

PHIL ROGERS

Phil Rogers was born in Newport, South Wales in 1951, and now works in Rhayader, a stunningly beautiful part of mid-Wales. Originally, Rogers trained as a secondary-school teacher, and worked in Cambridgeshire, before taking up full-time potting in 1978. He has written three superb books, *Ash Glazes, Salt Glazing* and *Throwing Pots,* and many feel that his ash-glazed pots are classics of their type. In recent years, he has focused slightly more on the salt-glaze kiln, and has become a master at this technique. He has recently built a three-chambered, climbing, wood-fired kiln, and currently this means that firing is demanding much of his attention.

As well as being a highly respected potter, he is an excellent teacher of the craft, and for 16 years from 1985 he hosted week-long courses at his pottery. These were much enjoyed and appreciated by the many who returned year after year, although it is arguable whether this was just for the pottery or also for the wonderful vegetarian meals prepared by Phil's wife Lynne! Although he has always had his workshop in Wales, he has also worked in Ethiopia, helping to run Project Ploughshare, a women's pottery project in Gondar. He has also demonstrated his techniques all over the world, particularly in the USA.

Wherever he works, Phil is very highly regarded; in Japan and Korea, he is almost revered by ash-glaze potters. He is represented in museum collections all over the world, including the Museum of Modern Ceramics in Mashiko, Japan. He is a member of the International Academy of Ceramics, but is particularly proud to be the only potter member of the Royal Cambrian Academy.

CAMILLE VIROT (FRANCE)

Virot pots in Banon, Provence, a remote part of France. His work is mainly raku. Although he makes excellent tea bowls, it is his larger pieces that are most interesting, as he often combines other materials, such as wood, clinker and lead with clay to produce unusual but fascinating containers. He studied ceramics at the school of fine art in Besançon and decorative arts at the school of fine art in Strasbourg. A visit to his workshop is rewarding, as the quality of his work is overwhelming.

WARREN MACKENZIE (USA)

Warren MacKenzie, arguably the most important living American ceramicist, was born in 1924 and worked at the Leach Pottery from 1949 to 1952. He now lives and works in Minnesota, USA. Much of his early work was very heavily influenced by Hamada, but he developed his own style, still bearing the trademarks of the Leach Pottery training, but distinctly his own. He makes 'everyday' objects which he desires should be used and handled regularly. His philosophy has always been to produce beautiful, but cheap and utilitarian, work. Potters and collectors in the USA quite rightly revere him, and many museums include his pots in their collections.

Opposite: Salt-glazed bottle by Phil Rogers, ht: 30 cm (11½ in). This bottle was fired on its front on shells. *Photo courtesy of the artist.*

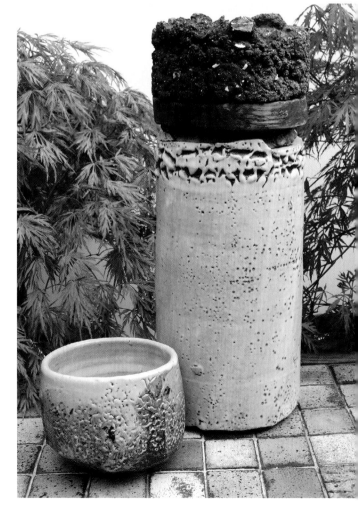

Below: Chawan by Camille Virot, ht: 10 cm (4 in). Container by Camille Virot, ht: 40 cm (15¾ in). Mixed media. *Photo by Alistair Hawtin, private collection.*

GORDON BALDWIN

Baldwin has taken his influences from many sources, including the avant-garde music of John Cage and Karlheinz Stockhausen and the sculpture of Jean Arp. He was born in 1932 in Lincoln, England. After studying at the Lincoln School of Art and the Central School of Art and Design, he began handbuilding pieces in the 1950s. At this time he was producing both functional pots and sculpture. All through his career, he has flirted with both, although his best work is very sculptural and, to my eye, very exciting. Unfortunately, it rarely comes on the market, but in my opinion is well worth looking out for. Through being represented by a specialist ceramics gallery, he has at last received the recognition his work deserves.

NIGEL WOOD

Nigel Wood's inclusion here may be a surprise to some of those who already collect pots, but his work is of the very highest quality, particularly because his glazes are incredibly good. His real interest is research into the technology of Chinese ceramics, but before he stopped potting seriously he made some very special pots at his workshop in West Meon in Hampshire, England.

Nigel Wood was trained at Berkshire College of Art from 1964 to 1965 and then at West Surrey College of Art and Design, Farnham from 1969 to 1972. His studies into the technology and history of East Asian ceramics, with particular reference to China and Korea, have resulted in several books and articles, including the excellent *Chinese Glazes*, published in 1999 (see Bibliography). He has lectured at The Royal College of Art and is currently an Honorary Research Associate at Oxford University and Professor of Ceramics at the University of Westminster. Often, his pots are only marked 'Meon', but I recommend that you look out for them, as you are unlikely to be disappointed.

Press-moulded dish by Nigel Wood, l: 33 cm (13 in). With kaki and clear glazes and trailed decoration. *Photo by David Binch, by kind permission of the artist, private collection.*

JOHN MALTBY

As I mentioned earlier, one of the best things about visiting potters whose work one admires is getting to talk to them. I visited John Maltby, and he was kind enough to discuss his influences and also his views on collecting.

John was born in 1936, studied at Leicester College of Art and worked with David Leach at Lowerdown Pottery from 1962 to 1963. Over the years, his work has evolved considerably from domestic ware to sculptural forms. He sees himself as a ceramic artist or ceramic sculptor rather than a potter, and his fertile imagination and prodigious and excitingly varied output reflects this view. Motivated by a desire not to stand still artistically, he has produced some of the most vibrant work in Britain today.

John's inspiration comes very much from his surroundings and the objects he has encountered throughout his life – things such as birds, flowers and landscapes. His influences are very much English and this can be clearly seen in his works; yachts, trees, church towers, figures from tombs and legends and features of the English landscape inspire him. Experience gained with Bernard Leach made him change his path in life and introduced him to clay. He didn't come across any other materials during that period of his life, and ever since has persisted with exploring the possibilities of clay. However, he has produced many wooden automata, influenced in some way by the work of Sam Smith, and these are as collectable as his pots for their idiosyncrasy and skill.

John's work is fascinating and his views on collectors are equally interesting. He feels collecting should only be for aesthetic reasons, and highly respects those who subscribe to this view. He has thus been disappointed to find that some do collect for other reasons. One collector who he thought enjoyed his work because he found it beautiful and exciting turned out only to be interested because he had some additional disposable income and an unfulfilled need to collect something! He feels that it is sad when you lose collectors, even though you gain others along the way.

Tiger with Rider by John Maltby, ht: 16 cm (6¼ in). Stoneware with applied slips and stains. *Photo by David Binch, by kind permission of the artist, private collection.*

John Maltby with Bill Ismay. In the background can be seen some of John Maltby's work. *Photo courtesy of Tony Hill.*

Some observations by Martin Browne, an avid collector of John Maltby's work

I first discovered John's work via a gallery in Yorkshire, which exhibited the work of potters and artists including the late Mick Casson and David Lloyd-Jones, Clive Bowen and Richard Batterham, all of whom I had been buying and collecting for several years.

As I come from Devon, I already had a strong interest in West Country ceramic artists, particularly those with St Ives and Leach links, so was naturally drawn to Maltby's work. His work challenged me to look at and question the pots, which were wheel-thrown with brown tenmoku and ash glazes, and so to broaden my own visual understanding of studio pottery. The seeds were sown, and that was 10–15 years ago.

John's work, not just his pottery but the paintings and automata, had key visual components that appealed to me – links with the St Ives art scene, particularly Alfred Wallis, another interest of mine. His work at the time I started collecting was hand-constructed, and integrated with some altered wheel-thrown forms, combined with the use of colours applied with bold brush and slip markings. It challenged my thinking beyond the Leach tradition in both forms and surface decoration, and so I entered into a new area of studio pottery collecting.

John is a potter who unlike many others of his generation has always been willing to adapt and change, trying out new ideas and moving on. Although his visual influences can be seen, his interpretations are personal and unique. A Maltby ceramic doesn't need his name on the base or plinth; his name is written all over it. He acknowledges the craft tradition in his own unique way like no other British studio potter. John's pots and sculpture acknowledge the past but live in the present.

Asked which potters' work he admires, he replied that he finds it hard to commit to claiming one person's work as more valuable aesthetically than another's because tastes change. Some of the Hamada pots he thought were 'most wobbly' are those he now appreciates the most, because he now understands more about what Hamada was trying to say. However, despite this reluctance to express a preference for other potters' work, he did admit that he greatly admires the imagination of Breon O'Casey and Sam Smith's wooden toys.

EDMUND DE WAAL

Edmund de Waal was educated at the King's School, Canterbury, England, where he was fortunate enough to have Geoffrey Whiting as a pottery teacher. After leaving school, he was apprenticed to Whiting for two years before reading English at Cambridge. He remained committed to making pots, and studied Japanese at Sheffield University before going to live in Japan on a scholarship in the early 1990s, where he spent much of his time researching Leach's activities and throwing pots. Through this experience, he has developed a style that, although rooted in the Anglo-Oriental tradition, is a complete rejection of the path Whiting followed. Despite his rejection of his mentor's teachings, he remains appreciative of the training he received and devoted to the memory of Whiting as a man.

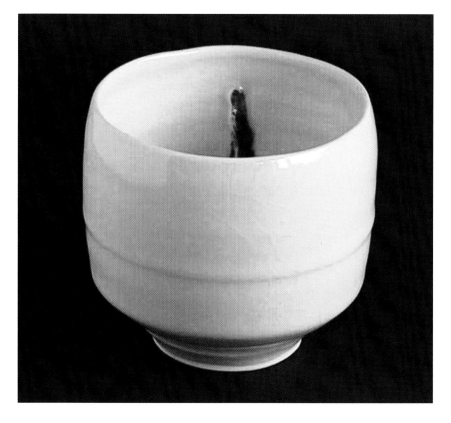

Porcelain tea bowl with copper splash by Edmund de Waal, dia: 11 cm (4½ in). The bowl was made for the *Totally Teabowls* exhibition. *Photo by David Binch, by kind permission of the artist, private collection.*

Eleven porcelain vessels by Edmund de Waal, lead-lined lacquered cabinet, 40 x 35 x 22 cm (13½ x 15¾ x 9 in). *Photo courtesy of the artist.*

He works in porcelain, his vessels often showing a contrived element of asymmetry, such as a slight dent or crookedness introduced while the pot is still on the wheel.

In recent years De Waal has been making installation groups, which he calls 'cargoes' of pots, inspired by the images of sunken cargoes of porcelain. The cost of these installations is often beyond the price range of many collectors. He has also made functional vessels, the likes of which can still be found in certain galleries (see previous page).

Hare by Emma Rodgers, ht: 14 cm (5½ in). Mixed media. Note the quality of the colouring and textures on this piece. *Photo by Alistair Hawtin, by kind permission of the artist, private collection.*

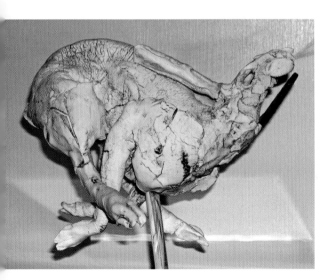

EMMA RODGERS

Emma Rodgers is, in my opinion, one of our most gifted sculptors of clay. Emma was born in 1974 in the North-west of England, and she began modelling in clay at the age of 10, focusing on animal forms from the age of 13. In her work, she tries to portray the character of an animal or figure, with the aim of capturing movement. To achieve this she does a large amount of visual research, including film, photography and drawing. She uses her superb sketches to capture the mannerisms and idiosyncrasies of animals, and it is her ability to capture the moment that makes her work so special. Her figures often have pieces missing, as she feels that this gives the viewer a better experience. They

have to imagine those missing areas, thus encouraging a more interactive engagement with the object.

Emma also makes human figurines, which have other pieces added, including feathers and pieces of jewellery, creating what she describes as 'sassy'-looking women! She uses a mixture of materials; the strength of the piece comes from Earthstone clay, while porcelain lends it plasticity and translucency. Many of her pieces have also been cast in bronze. Emma is based in the Wirral in Cheshire, England.

Monkey by Emma Rodgers (detail). *Photo courtesy of the artist.*

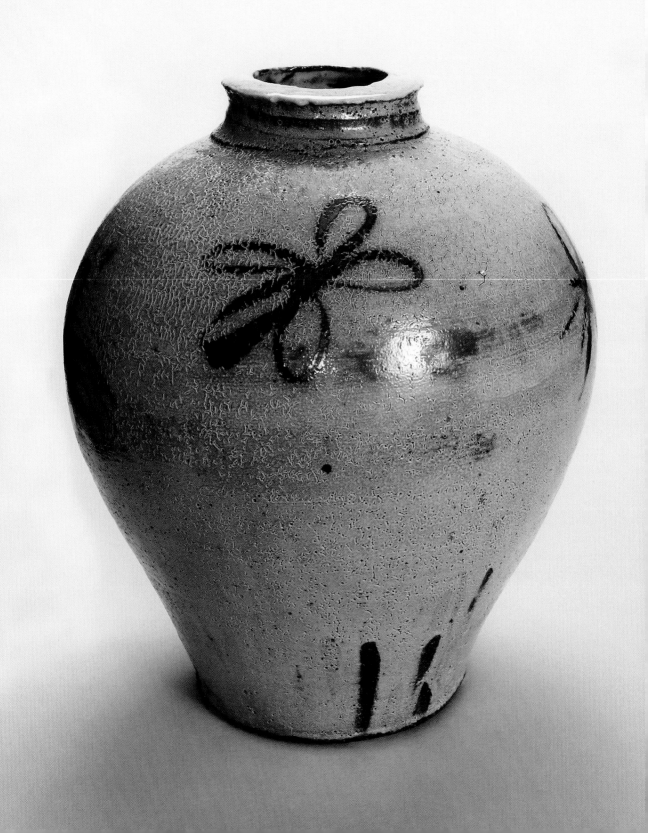

Should I Buy Perfect or Damaged Items?

As a rule, try to avoid buying flawed or damaged pots. However, some forms of flaw or damage are worse than others: pots that have been damaged in the process of firing should be quite acceptable providing the damage does not detract from the beauty of the piece.

Illustrated is a celadon bowl made by Bernard Leach which, when removed from the kiln, was found to have a split on the rim. Most types of clay, particularly porcelain, are prone to this problem – especially with large pieces, where the rims undergo a great deal of stress.

The fluted celadon bowl shown was repaired by Bernard Leach himself shortly after the flaw was discovered. He used a gold-lacquer repair, a method highly regarded by the Japanese. A repair of this kind will not necessarily detract from the value or the beauty of the pot. Minor chips *will* devalue it, but these can be professionally repaired at little cost, either with an invisible repair or, if you prefer not to hide damage, with one of gold lacquer. Although a break will seriously devalue a piece, even broken pots can be made beautiful.

One type of flaw in a pot that should be avoided is the bloat. Bloats are bubbles inside the clay body, and therefore beneath the surface of the glaze, which have made a small area of the pot bulge during firing. Little can be done about bloats and they never look attractive.

The danger of expert repairs is that they are often hard to detect. Although you can check closely with the naked eye, if you are spending a large amount of money always ensure that you get a receipt stating that there is no damage, or get an expert opinion.

Above: Detail of fluted bowl by Bernard Leach *(see p.96).*

Opposite: Salt-glaze vase by Anne Mette Hjortshøj, dia: 25 cm (10 in). *Photo courtesy of the artist.*

Fluted celadon-glazed bowl by Bernard Leach, 22 cm (8¾ in). Damage from firing can be seen on the right of the bowl and also in the picture on p.68. It in no way diminishes the beauty of the bowl. *Photo by David Binch, by kind permission of John Leach, private collection.*

Below: Bill examining the repaired charger. *Photo by Alistair Hawtin, by kind permission of Marjorie Marshall, private collection.*

If you do buy a damaged piece or you damage an item in your own collection, it is not the end of the world. Assuming that you have your pot insured, either under the general household insurance or as part of a separately insured collection, you will be able to replace it. Of course, the unique nature of these pots means that you will never find one exactly the same, but you should be able to replace it with a comparable item. Another possibility is to get the pot restored by a reputable ceramics restorer.

Shown here is a huge charger by Bill Marshall, my first major purchase and the pot responsible for my becoming a collector. One Sunday afternoon I was standing on my bed storing something on top of a wardrobe when I caught my foot in the duvet cover. I crashed to the floor, followed shortly afterwards by my precious Bill Marshall charger, which not only smashed to pieces but also brought a number of jugs and yunomi with it. Needless to say, I was somewhat upset. However, I had it restored by a professional restorer, Fiona Hutchinson, with a gold-lacquer repair. When I took it in trepidation to Bill Marshall to confess my clumsiness, he said in

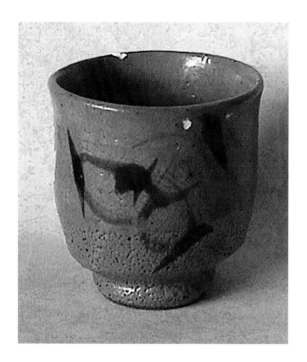 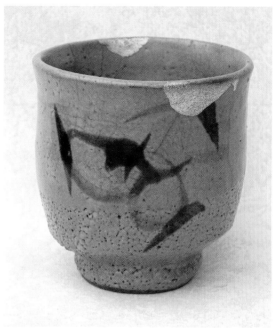

Above: Two views of the same yunomi by Shoji Hamada, showing (a) the apparently small amount of damage as described by the auction house and, (b) the actual damage as shown by the gold lacquer repair! *Photo by Alistair Hawtin, by kind permission of Tomoo Hmada, private collection.*

his wonderful, broad Cornish accent, 'She's made it more beautiful than I ever did, boy!'

Something else to beware of is buying incomplete pots. You are probably saying to yourself, 'How can anyone do that?' You would be surprised how many coffee pots are sold as jugs and lidded pots as bowls. The simplest way to avoid this particular problem is to check whether or not the rim of the pot is glazed. If it is not glazed, it probably once had a lid. Another more subtle example of an incomplete pot is one that has part of it missing. Many sculptural pieces are composite pots made from a number of pieces and/or clays, which deliberately have the appearance of being broken, often for artistic effect. In this case, all you can do is ensure that there are no fresh breaks! In recent years, epoxy adhesive has become a part of the sculptural potter's armoury, so do not be surprised if a composite piece has been assembled using glue!

Nowadays, damaged pots can be repaired so well that it is very difficult to spot the damage. Antiques experts will test suspicious areas with their teeth. I would not recommend such a tactic, but if you do have any concerns about a pot, get a second opinion. In some cases, if you are happy with how the pot looks, do not be too suspicious – just live with it!

One final warning: many Japanese pots were originally sold with signed wooden boxes. If the pot is advertised by the seller as being with a signed wooden box, ensure that the box comes with it and that the box is the correct one. A pot sold with a box is likely to be at least one third more valuable than one without.

Where Can I Buy Ceramics?

Buying from galleries

Galleries have always been important in the support, exposure and development of studio pottery. In 1928, Muriel Rose opened the Little Gallery at 3 Ellis Street, off Sloane Square, in London. This was the first centrally placed gallery that championed craft on a level with fine art. The gallery moved to 5 Ellis Street in 1935 and continued there until 1939. The gallery was only open for 11 years, but Rose's influence continued until her death in 1986.

Born in 1897, Muriel Rose was a leading advocate for 20th-century British craft practitioners and a founding trustee of the Craft Study Centre in Bath, England's first purpose-built museum for a modern craft collection. When she died in 1986, Rose left a lasting mark on the history of the modern crafts movement.

The war years were lean times for most people, and potters were no exception, but in 1946 Henry Rothschild opened Primavera at 149 Sloane Street in London. Rothschild sold pots by the Winchcombe and Crowan potteries and in 1948 first showed pots made by Lucie Rie. This was followed up in 1958 by Hans Coper's first one-man show. Rothschild opened a second Primavera shop in Cambridge in 1960. Rose and Rothschild cannot be underestimated as pioneer gallery owners; theirs were the forerunners of many later craft galleries.

Buying from a gallery almost guarantees that you will be buying a potter's best current work. Gallery owners usually have a good eye and may be involved in the selection process for an exhibition or show. They are also usually very approachable and knowledgeable about their subjects; such

Above: Detail from earthenware figures by Geoff Fuller, *(see p.107).*

Opposite: A vase by Katharine Pleydell-Bouverie, ht: 6 cm (2½ in). Found in a charity shop. *Photo by David Binch, private collection.*

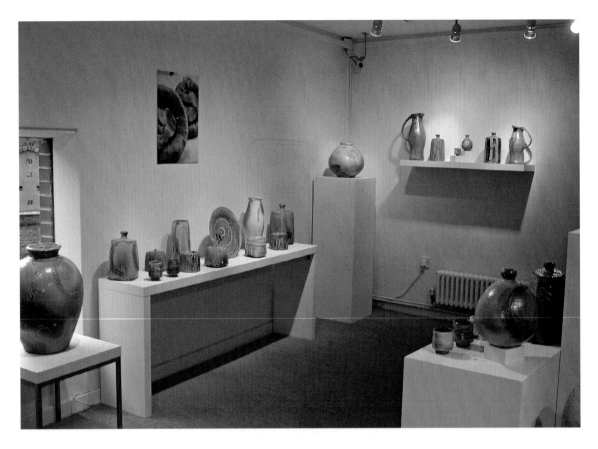

Interior of Goldmark Gallery, in Uppingham, Rutland, during a show of work by Lisa Hammond. *Photo by Alistair Hawtin.*

knowledge is often born out of a passion for the subject. Remember, though, that a gallery has to be financially viable and therefore a mark-up of between 30–50% will have been added to the trade price.

In recent years, galleries that sell mainly pots have been going through hard times. The rise of the internet and an increase in the number of potters' events means that many galleries have been forced to close.

Despite this, there are still a number of very good galleries run by committed and knowledgeable proprietors, and a list of some of these is included at the end of the book. In fact, one recent trend is that galleries who have specialized in fine art are beginning to sell and promote ceramics in the same way as paintings and sculpture. Currently, it is hard to judge whether this will be a great success in the long term, but the signs are very promising. Many galleries are only open on certain days of the week, as gallery owners need to spend some of their time finding good new pots. The nature of the business makes it advisable to ring first, to ensure that a gallery is both still in existence and open on the day you wish to visit.

Many galleries keep pots in stock all the time and can show you a good representative selection of certain potters' work. As well as keeping a regular stock, most also hold exhibitions of the work of some of the better-known ceramic artists. It is a good idea to place your name on their contact lists.

These days they often contact you by email, but many still also have mailing lists. Small advertisements in magazines such as *Crafts* or *Ceramic Review* are other places where forthcoming exhibitions are sometimes announced, while a further good source of information in this regard is the internet. At the current time, two particularly good sites to keep a watch on are: http://www.studiopottery.co.uk/index-f.html and http://www.ceramike.com/index.htm.

David Binch with Lisa Hammond in the Oakwood Gallery, which is now run purely online. *Photo by Alistair Hawtin.*

When an exhibition is announced, if you really want the very best pots you will have to attend the private view. This is likely to be held either during an evening (often a Thursday) or on a Saturday or Sunday. Many galleries hold an opening at around lunchtime, to allow visitors coming some distance to get there in time for the opening. You may have to queue, or take your turn in a system of numbers. Some galleries only allow punters to purchase one or two pots at a time, and you may have to wait quite a while for the queue to be dealt with once, before you get a second chance.

Collectors have been known to camp overnight in order to be first in the queue, only to oversleep and find that someone who arrived at 5 a.m. was there first! These are the true 'potaholics', who may be envied or pitied to the same extent, depending on one's point of view!

It is worth remembering that there is no successful way to ensure that the purchase of pots from an exhibition's private view is completely fair. What

The thrill of the chase: buyers queue outside the Oakwood Gallery, awaiting the opening of the *Totally Tea Bowls* exhibition in 1997. *Photo by Alistair Hawtin.*

you can be sure of is that the gallery owners have done their best to make it as fair as possible, so don't be too critical if you fail to get the pot you want!

The Web addresses of some of the best UK galleries are included in the list at the end of the book (see p.126).

Buying from the potter

There is nothing quite like visiting potters in their place of work. If, like me, you are interested in what makes someone tick – how where they live and work influences the pieces they make, what their other influences are, and how they set about their work – you cannot do better than visit them. Beware, though – it is always advisable to contact them before you visit, particularly if you would like a chat! For many, the daily routine involves a fairly rigid pattern of work that it would be hazardous to interrupt. For example, if a potter has made a batch of teapots and is in the process of attaching spouts, to break off working could result in the spouts becoming too dry to use. With some warning of a visit, a potter can arrange for a pause in the manufacturing process so as to talk to you. Alternatively, if you do turn up unannounced, do not think that the potter is being unfriendly or rude because he or she does not talk to you much. Making ceramics is his or her chosen profession, and even a successful potter has to create an awful lot of pots in order to make a living; the show must go on!

In truth, not all potters really enjoy being visited, particularly without warning; some have chosen this rather solitary profession *because* of the isolation and solitude. However, in my opinion the pot does reflect the man (to paraphrase Bernard Leach), and the majority of potters are delighted to see a friendly and appreciative face.

Most potters have their own galleries with stock available for visitors to buy, but in many cases the work they are currently making will be for an exhibition or a gallery, and much of the work at the pottery may already be reserved for this purpose. For this reason, many of the pots available for purchase may be either old stock, seconds, or pots the potter does not rate very highly. You may be lucky to find a gem amongst the fare available, but do not be too disappointed if there is nothing you really want. Conversely, do not think that the potter expects you to buy something. Many collectors who visit potteries try to find something as a memento of the occasion, but you may find that the item you choose is little more than that.

It is worth remembering that in order not to undercut galleries, many potters charge the retail price for the best pots available at the pottery. If a pot is cheap, it may not be one of the best. Some ceramics bought as seconds from potters by slightly unscrupulous dealers find their way onto the internet. Check that you are not paying over the odds for seconds. Some potters, for philosophical reasons, sell their work very cheaply from their workshops. This leaves them open to exploitation by unscrupulous dealers

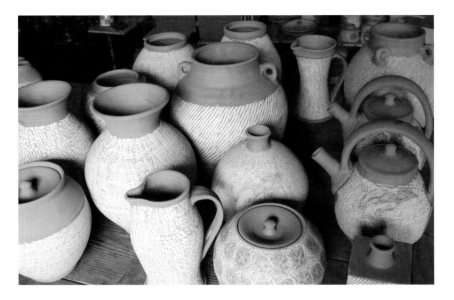

over the internet. Warren Mackenzie, in Minnesota, is among the principled potters who fall victim to this practice.

Finally, many potters live in very remote areas where raw materials are readily available, property is cheap and they do not expect too many interruptions. Be prepared to travel!

Left: Biscuit ware awaiting glazing at Tatsuzo Shimaoka's workshop in Mashiko. *Photo by Alistair Hawtin.*

Above: A visit to Jim Malone's pottery. *Photo by Alistair Hawtin, by kind permission of the artist.*

Buying from auction houses

Several major auction houses specialize in selling contemporary ceramics, either in a dedicated sale or as part of a 'modern design' sale. The most active of these currently is Bonhams, who have auction rooms in many major towns and cities around the world.

If you buy from a major auction house, you can expect to be purchasing at the top end of the market. You should have an excellent selection, but you will also be paying top prices. Remember that, in order to make a profit, auction houses have to charge a commission to the buyer, which may be up to 20% on top of the hammer price. They also hold viewing days, and these are well worth attending. As well as being able to see and handle top-quality pieces, you will also be able to gather more information about the sale, and knowledge about the pots from the ceramic specialists on the auction house staff, who are usually very willing to share their expertise. Recently, the market has become more polarized, with the top pieces commanding higher prices than ever and the remainder staying relatively affordable. Auction houses are beginning to offer a wider choice of top-class ceramics unfamiliar to their usual public. Although you may need reassurance that you are buying the right piece, it is often worth being led by their experts. The internet has changed the way that auction

houses conduct their business, affording clients the opportunity to research their collections, and helping people see what is going on outside their own country.

It is also possible to subscribe to their catalogue mailing service, which is well worth doing if you are serious about purchasing from an auction or you like well-compiled catalogues with top-quality images.

For the same reason that it is possible to buy bargains from antiques fairs, it is also possible to find an unknown gem in an auction. Particularly in provincial sales, an auction house cannot have experts in all fields, and just occasionally a very special pot may escape their eyes. I know of a large and important Hamada, worth in the region of £3,500, which was bought in Somerset, England for about £200; and I, myself, bought a Hamada chawan for about £40 in a job lot of four pots from a very reputable auction house. Sometimes other errors are made; in one contemporary ceramics auction in London I once saw a Chinese Sung Dynasty tea bowl catalogued as 'a small, unmarked brown pot, estimate £30–40'!

Below are some useful websites relating to auctions:

www.phillipsdepury.com

www.christies.com

www.antiquestradegazette.com

www.bonhams.com

Buying from antiques fairs

The antiques trade has very few sellers who specialize in contemporary ceramics, even though work by many of the early studio potters has become very valuable. There is still not an enormous amount of knowledge in this area, though it is growing. Many dealers will know the most famous potters' marks, but not their styles. Be very careful when purchasing from antiques fairs as pots may be misrepresented, either inadvertently or deliberately.

Dealers tend to be very cautious, and many will put high prices on any studio pieces to avoid being 'taken for a ride'. If you are not sure, do not buy. Occasionally you will pick up a bargain, but usually it will be an unmarked item that you recognize by style; developing the ability to be able to do this takes time, so beware.

The best antiques fairs are usually held midweek and so are less accessible to many of us, but they are certainly worth visiting, if only for the fun of browsing for both studio pottery and source items. Probably the best fairs to visit are those advertised on the internet. At the time of writing examples include:

www.dmgantiquefairs.com (UK)

www.collectingnetwork.com/links/antiqueshows.html (USA)

www.goantiques.com/community/show_promoters/index.htm (USA)

www.aada.org.au/events_fairs.cfm (Australia)

Car boot sale at Ford, near Arundel in Sussex. Sometimes these offer treasures, and sometimes nothing at all.
Photo by Alistair Hawtin.

Buying from car boot fairs, jumble sales and charity shops

Car boot fairs used to be a very good source for contemporary ceramics, and from time to time bargains still surface. Even if you find nothing, it is fun trawling for treasures while at the same time keeping fit by walking up and down between long rows of cars!

I am an avid car boot fairgoer. 'Car booting' is almost a separate addiction in itself, but the same discipline needs to be applied to booting as to buying pots: be selective about what you collect!

In the past, I have found a complete coffee service from Bernard Leach's St Ives pottery for the princely sum of £4, a beautiful slipware-decorated Michael Cardew tankard for £1, and numerous pieces by lesser-known potters. I also know of a Cardew coffee set that was unearthed in the Midlands and, as mentioned before, a Hans Coper dish that eventually sold at auction for almost £20,000. Punters have also found a Charles Vyse bowl for £1, a Lucie Rie cup and saucer for £1, and an exquisite Bernard Leach decorated tile for 50p, which later came to be featured on BBC Television's *Antiques Roadshow*. Searching for good pots at boot sales is great fun, and even if you find nothing, the excitement of thinking that you might spot a Bernard Leach from 30 metres is almost as satisfying.

As well as the many stories about genuine finds, there are also many apocryphal tales, including, for example, a collection of Hamada's pots found at Brighton Station Boot Fair. This particular part of the story has apparently been verified, but it is also rumoured that the seller threw away the signed wooden boxes that came with the pots, as he could not be bothered to carry them! If this were true, had he kept hold of them he would have increased the value of the pots by between a third and a half! So if you ever see a pot with a box, make sure that you buy the box too.

Although it is worth scanning all the stalls, quite often the best sellers to focus on are people who look as if they might be selling the contents of a home. There is often something interesting that clearance people may have overlooked. In the past I have found a collection of pots by Katharine Pleydell-Bouverie from just such a source, and more than one Leach Pottery item. Moreover, jumble sales or yard sales are equally interesting to browse through; occasionally something interesting turns up, so keep your eyes open.

Another good place to search for contemporary ceramics is a charity shop. Notwithstanding the fact that there are some ethics to deal with here (is it right to buy very valuable items from charity shops for a pittance?), they can be good sources for relatively cheap pots. In the last ten years, charity shops have become much more aware of the value of collectable items and often have their own experts to vet donations. Despite this, many pots do slip through the net. I know of at least two Katharine Pleydell-Bouverie pots found in such shops, and a Korean-style pot by Bernard Leach that eventually sold at Bonhams; not to mention numerous pieces of St Ives standard ware.

Ah, the ones that got away! Nowadays it is still possible to find good items in such places, though usually not major ones. Part of the problem, and something that to some extent this book may address, is the lack of knowledge of this area of collecting among dealers in the second-hand or antiques trades. There is enough knowledge to recognize that handmade items can be valuable and a feeling that when bought at auction the particular handmade item found in Granny's house, or in the bottom of the tea chest, could be one of these valuable ones. In order not to be taken for a mug, the dealer immediately slaps a high price on it! When challenged about the authenticity of a piece, one particular character who I met regularly at boot fairs always used to tell me, 'It's in the book; it's in the book, mate!' Which particular book, I do not know, but being 'in the book' obviously gave the nasty, evening-class-produced item signed 'Judy '85' a huge value.

The best way to find good boot fairs is to consult any local newspaper, look online or ask the locals. Most reasonably sized towns have charity shops, and do not be put off by the fact that there is only one in a particular place; my favourite charity shop is the only one in the village. Websites to use for car boot sale information are: www.carbootjunction.com and www.carbootcalendar.com. Happy hunting!

Buying from ceramics fairs

By ceramics fairs I mean sales outlets organized by potters' associations or in conjunction with potters' associations, not mixed-media craft fairs, at which, with a few exceptions, you are unlikely to find wares of high quality.

Over the past few years, the rise in the number of fairs in which ceramicists

Earthenware figures by Geoff Fuller, ht: 25 cm (10 in), at Rufford. Geoff Fuller's work, like John Maltby's, is very much based in the English tradition. It often represents folk tales, and incorporates humour and irony. *Photo by Alistair Hawtin, by kind permission of the artist, private collection.*

sell their own wares has been quite remarkable. There are a number of views about the value of these events, some of them opposing. One angle is that the potters come into direct contact with their appreciative public and cut out the middleman, thereby increasing their profits; another is that potters are biting the hand that feeds them by killing off the galleries upon whom they have relied for so many years.

Whatever the case, there are other considerations that need to be addressed; for instance, does one get the best pots at a fair, or is the potter merely clearing out dead stock? If the latter should be true, would a buyer be better served buying from a known gallery, where, even if the price were higher, quality would be guaranteed? Another issue to consider is whether you are using your time efficiently visiting a fair where there may be 50 potters producing inferior-quality ceramics, or where the majority are selling wares that are not to your taste and only one or two make pots you like. If your judgement is skewed by seeing a favourite potter's pots shining like diamonds in the coal dust (when actually the pots are not that good), how disappointed will you be upon returning home to find that your new purchase looks dull?

Having alerted the unsuspecting to the pitfalls, it has to be said that some of the finest fairs are well worth a visit. At the time of writing, the best of these fairs in the UK, in my opinion, are the International Ceramics Festival at Aberystwyth; Earth and Fire at Rufford, near Centre Parcs, Nottinghamshire; and the summer-held Art in Clay fair at Hatfield in Hertfordshire. All are efficiently run, and many of the best potters can show off their wares in interesting surroundings. Others that are worthy of investigation are listed overleaf.

• The COLLECT exhibition at the V&A Museum in London is a good top-end-of-the-market show (nothing less than £500!), as are:
• CAL, the Ceramic Art London show at the Royal College of Art
• Clay Art at Denbigh
• Perth Potfest in Scotland
• Oxford CPA Show
• Art in Clay at Farnham in Surrey, held in November
• The Potfest South-West, held in September
• The Potfest in the Park, held at Hutton-in-the-Forest, near Penrith in Cumbria.

Ian Gregory demonstrating at Earth and Fire, Rufford, 2005. *Photo by Alistair Hawtin.*

It is interesting to note that high-priced pots are sold in shows such as COLLECT or CAL, whereas in Japan pieces commanding very-high prices are sold in department stores. Imagine Debenhams or Selfridges hosting such shows!

In the USA, the NCECA (National Council on Education for the Ceramic Arts) holds a fantastic convention in Pittsburgh, and the SOFA (Sculpture, Objects and Functional Art) exhibitions at Miami and Chicago are exceptional. There are also a lot more demonstration weekends tied to exhibitions than there are in the UK – for example, the Strictly Functional weekend is well-attended, and the North Carolina Potters' Conference is a regular event.

Earth and Fire, Rufford, 2005. *Photo by Alistair Hawtin.*

An interview with Ben Williams, auction house specialist

Q. What drew you to collect studio pottery in the first place?
A. It was always around me at home when I grew up, but it wasn't a conscious decision for me. I think I could have taken other paths but I was drawn in this direction by an affinity with the people that I came into contact with and their willingness to share their experiences and observations with me.

Q. Which potters do you most admire and why?
A. Hans Coper, because I never tire of looking at his work, trying to make sense of where that particular piece fits in to the evolution of the other forms that I know of; Shoji Hamada, for his apparently effortless ability to produce so many works and make each one appear so fresh; Akiyama Yo, for the unique way that he works the clay, pushing its capabilities whilst retaining a deeply held understanding and respect for the material; and Bodil Manz, for the sheer beauty of her work.

Q. What criteria do you use when selecting which pots to buy?
A. I find it difficult to buy and sell pots without there being a huge conflict of interest. I do own some but I wouldn't say that I have a collection.

Q. Of current potters, whose work do you think will be the antiques of the future?
A. Clearly there are big names working at the moment who are already seen in museums and galleries and also have their work published widely – Grayson Perry, Magdalene Odundo and Elizabeth Fritsch, for example, are sure-fire examples of people who will not just disappear as so many potters seem to.

Q. Which little-known potters would you recommend people investigate?
A. I think that, in the UK, Nic Collins and Chuck Schwartz produce interesting work. Many Japanese potters are superstars in their own country; but because their domestic market is so strong they aren't ever seen here. If you can find them then works by Kohyama Yasuhisa, Kaneshige Kosuke and Fukami Sueharu will give you an insight into this market.

Q. Which pots would you consider iconic studio pots?
A. The Bernard Leach Tree of Life dish in the V&A in London, the Adelaide Robineau Scarab Vase in the Everson Museum, Syracuse, and Mr Samsa's Walk by Yagi Kazuo in the Museum of Modern Art, Tokyo. There are also what I would consider iconic forms too: Betty Woodman's 'pillow pitchers', Peter Voulkos's 'stacks', Lucie Rie's 'flaring-lip vases' and Hans Coper's 'spade forms', for example.

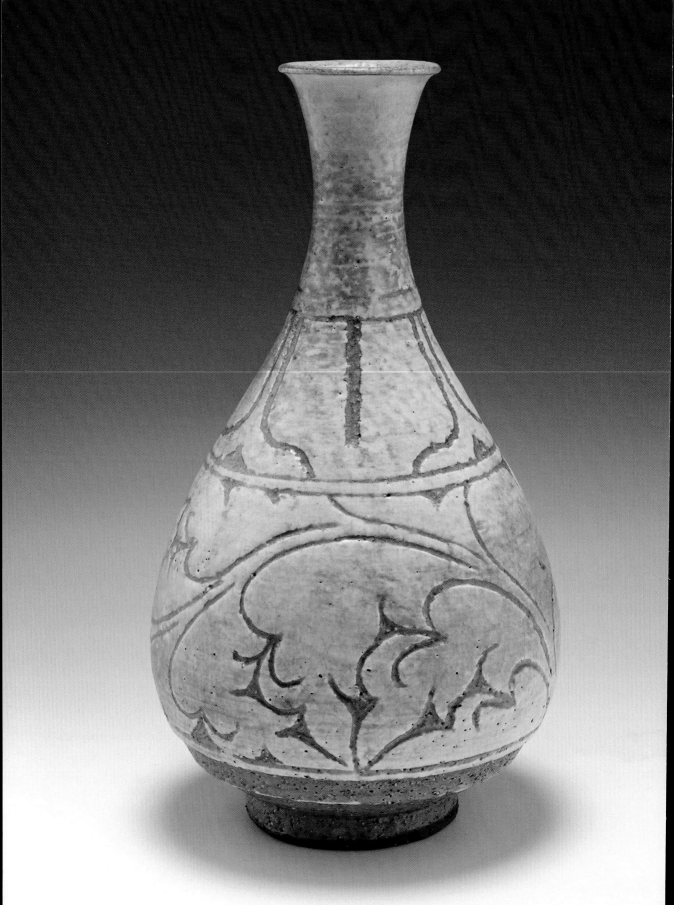

Collecting Complementary Items

Although this section of the book does not deal with contemporary pottery, it is still very important and, I hope, interesting.

Most potters would admit to having been influenced by the pots of the past. Even if the influence has been a negative one, in that the potter may have deliberately made pots that are *not* like Sung Dynasty Chinese or medieval slipware, it has still been a conscious rejection.

Bernard Leach was very clear on this matter. When nearing the end of his life, and wanting to leave his source collection to the Craft Study Centre, then at the Holburne Museum in Bath, he wrote to Muriel Rose, 'The more I have considered the matter, the more I have come to the conclusion that the omission of examples of work from the past, which has proved vital in stimulus to craftsmen of the present century, is losing the opportunity of showing the public the connection between 20th century craftsmen and the past.'

To complement your collection of contemporary pottery, it is worth considering adding a few pieces from the past that show where the potter has gained influence, or a piece of artwork that has associations with the work you collect. For example, if your collection consists of pots made by Bernard Leach, Phil Rogers, Shoji Hamada, Jim Malone and Mike Dodd, you might like to have a few pots from the Korean Choson (Yi) Dynasty, or the Chinese Sung Dynasty, or Japanese Mingei items. You might also like to have a few oriental prints on the walls, or perhaps some furniture from the Far East.

Above: Detail from salt-glazed mug *(see p.113).*

Opposite: Korean Bottle, Yi Dynasty, ht: 31 cm (12¼ in). *Photo by David Binch, private collection.*

Korean chest with ash-glazed bottles. Bottles by (from left to right): Shoji Hamada, Bernard Leach and an unknown Korean potter from the late 18th century. *Photo by Alistair Hawtin.*

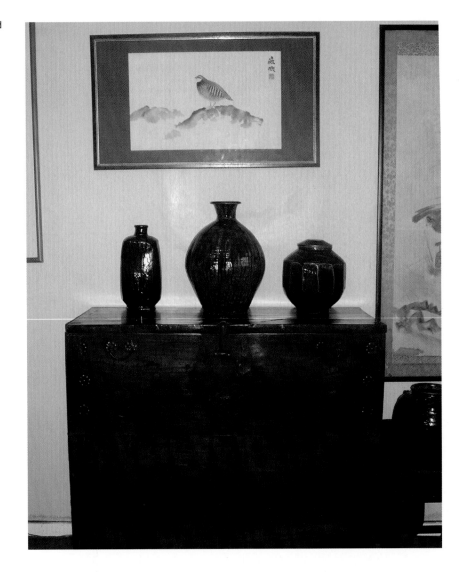

Collectors of Sarah Walton, Hans Coper or South Heighton potter Chris Lewis, on the other hand, might have a few artefacts from the Greek Cycladic civilization. Collectors of salt-glaze pots such as those made by Jane Hamlyn, Walter Keeler or Steve Harrison might want some late-medieval salt-glaze pottery and a few industrial items such as oilcans and blowlamps.

Some potters also draw or paint, and a framed picture by a potter can complement a collection beautifully. Emma Rodgers, for example, does the most exquisite drawings from life, and Robin Welch often displays his own ceramic work with canvasses behind. John Maltby is well-known for making wooden automata. These are now as collectable as his ceramic work. Shoji Hamada, Bernard Leach and Phil Rogers have executed some very distinctive etchings and prints, which may ultimately prove to be as highly thought of as their pots.

Salt-glaze mugs, 15th–17th century, ht: (left) 11 cm (4¼ in), (right) 16.5 cm (6½ in). *Photo by David Binch, private collection.*

Below left: Bottle illustration by Shoji Hamada. *Photo by Phil Rogers, by kind permission of Tomoo Hamada, private collection.*

Once again, the same warning applies about gathering source items! Just a few pieces can complement a collection; too many will swamp it.

Below right: Sketch of a tea bowl by Phil Rogers. Photo courtesy of the artist.

An interview with Steve Uchytil

Q. What drew you to collect studio pottery in the first place?
A. *Pottery is only one of the art forms that I collect, but around 1990 I came across some that were made by a fellow I knew from high school. When my wife and I saw the pots, we decided we would get one. That was the beginning of my pottery collecting and a nurturing of an aesthetic understanding of the medium.*

Q. Which potters do you most admire and why?
A. *As a collector, it's partially dependent on what I can afford, or am willing to afford. Now, if money were no object, then potters that I truly admire are Shoji Hamada, Tatsuzo Shimaoka, Kanjiro Kawai, Toyozo Arakawa, Kei Fujiwara, and many Hagi potters, such as Miwa Jusetsu, Kaneta Masanao and Kaneta Sanzaemon. I also admire Bernard Leach, Brother Thomas, Hans Coper, Richard DeVore, Magdalene Odundo and Peter Voulkos.*
Amongst the potters that I admire and can afford there are:
Japan: Ryuichi Kakurezaki, Takahashi Rakusai, Shibuya Deishi, Yamane Seigan.
UK: Richard Batterham, Mick Casson, Mike Dodd, Jane Hamlyn, Lisa Hammond, Walter Keeler, David Leach, Jim Malone, John Maltby, William Marshall, Phil Rogers, Geoffrey Swindell, Ruthanne Tudball, Takeshi Yasuda.
US: Paul Chaleff, Tom & Elaine Coleman, Val Cushing, Randy Johnston, Karen Karnes, Warren MacKenzie, Jeff Oestreich, Don Reitz, Jeff Shapiro, Michael Simon, Chris Staley, Byron Temple.

Q. What criteria do you use when selecting which pots to buy?
A. *I buy pieces that I am attracted to. It may be the shape, the glaze, the potter who made it, or sometimes just because a piece fills a gap in my collection. We often buy functional pieces, but many pieces are decorative objects. One of the attractions of pottery is the tactile aspect of the art form. There is no better feeling than to hold a pot in your hands, feel the potter's finger or hand impressions, and know that these 'clay fossils' have preserved the maker's hand marks and aura. There are few art forms in which one can do that.*

Q. Of current potters, whose work do you think will be the antiques of the future?
A. *Folks that I collect that I believe have 'investment' potential are Richard Batterham, Mike Dodd, Ken Ferguson, Lisa Hammond, Randy Johnston, Karen Karnes, Walter Keeler, Warren MacKenzie, Jim Malone, Jeff Oestreich, Phil Rogers, Jeff Shapiro, Dave Shaner, Michael Simon, Chris Staley, Byron Temple.*

Q. Which little-known potters would you recommend people investigate?
A. *I am prejudiced because these two folks are good friends, but Greg & Terese Melis are wonderful potters living the tough life of being studio potters in Northern Wisconsin. Others I would recommend are Craig Bird, Matthew Blakely, Wayne Branum, Amanda Brier, Robert Briscoe, Linda Christianson, Tony Ferguson, Wil Gebben, Chris Keenan, Maren Kloppmann and Jan McKeachiel.*

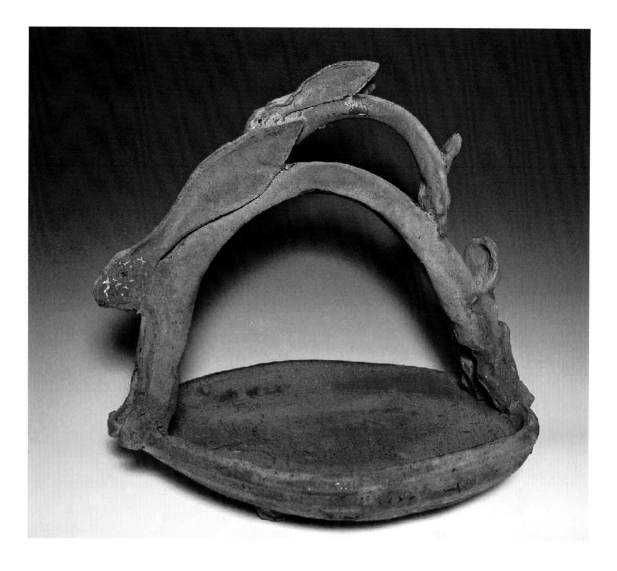

Leaping Hare Basket by Ken Ferguson, ht: 24 cm (9½ in). *Photo courtesy of Steve Uchytil.*

Q. Which pots would you consider iconic studio pots?

A. *In the Museum of Fine Arts in Houston, Texas is an incredible Magdalene Odundo vessel that just exudes life. It's very sculptural, but also very functional-looking. In books, I have seen fantastic Hamada and Shimaoka vases, platters and tea-ceremony objects. A Bernard Leach 'Leaping Fish' vase is something to behold. My favourite piece of studio pottery in my collection is a hakeme tea bowl by Jim Malone. All that is wonderful in studio pottery, for me, I find in that tea bowl. Another piece that I have in my collection that I am overwhelmed by is a 'Ribbon Pot' from American potter Chris Staley. It is just a magnificent vessel.*

WARREN MACKENZIE

Hare's Fur, Tortoiseshell, and Partridge Feathers Har

MICHAEL CARDEW: A PIONEER POTTER

POTTERS ON POTTERY

Potters Twelfth Edition

BRITISH STUDIO POTTERS' MARKS YATES-OWEN AND FOURNIER

HOGBEN The Art of Bernard Leach

Rice British Studio C

G. St. G. M. Gompertz KOREAN POTTERY & PORCELAIN OF THE YI PERIOD

ceramics for the home Annab

Leach HAMADA, pott

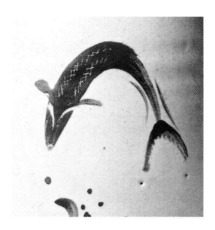

Which Books Would Help Me with My Collection?

Although strictly speaking it is not pot collecting, assembling a group of books to support one's hobby is a vital requirement. To assist you in this task, there is a bibliography at the end of this book. Between them these volumes will enlighten you on certain aspects that are central to any understanding of studio pottery, which will also help you set benchmarks for your own collection.

For a start, you will need a book that provides you with a comprehensive guide to both the whereabouts of potters and the distinctive potter's mark each one uses on their pots. The Craft Potters' Association (compiled by Emmanuel Cooper) produces a guide to the potters, called, until recently, simply *Potters*, it is now called *The Ceramics Book*. Unfortunately, it does not appear on a regular basis, and thus you will often have to work with out-of-date information, but it is still the most useful volume available.

As well as getting the most recent of these *Potters* books, it is also worth trying to find the old ones by searching the internet. If you are going to collect pots made by potters who are no longer alive, three books are particularly useful in this field. There is an excellent book on potters' marks by Eric Yates-Owen and Robert Fournier called *British Studio Potters' Marks*; however, it does have gaps, which you will need other books to fill. The book by Oliver Watson on the collection at the V&A Museum is very good because it contains a comprehensive photographic section of potters' marks. Its greatest limitation for a current collector is that it only covers the pots in the collection at the time it was written – 1986 – which means that a good number of collectable, more recent potters are not represented.

Above: Detail from *Leaping Salmon Vase* by Bernard Leach *(see p. 119).*

Opposite: Books that will help develop your knowledge of studio pottery. *Photo by David Binch.*

Another extremely useful book, covering this area as well as many others, is *British Studio Ceramics* by Paul Rice. It has a good section on marks, but is by no means comprehensive; I would recommend that you try to buy a copy of all three books I've mentioned to make sure you've got all the information you need.

An invaluable book for British collectors of contemporary ceramics is *A Guide to Public Collections of Studio Pottery in the British Isles*, again written by Robert Fournier, this time with his wife Sheila Fournier. Although this is no longer in print, it is well-worth searching for on the internet, or in second-hand bookshops.

If you want to understand something of the methods used by potters and the rationale by which a great number of them operate, then *A Potter's Book* by Bernard Leach is essential reading. Many potters began their careers by acquiring and absorbing this book. Written in 1940, it is still the seminal book on techniques and it is still in print.

Two other books of historical importance are Muriel Rose's *Artist Potters in England* and Sarah Riddick's *Pioneer Studio Pottery – The Milner-White Collection*. Rose's book was first published in 1955 and revised and reprinted in 1970, and covers the majority of studio potters from the early era. Muriel Rose's Little Gallery was one of the first in Britain to exhibit studio pottery on a regular basis. The book is one of a large series of monographs published by Faber. Although this is the only one on studio pottery, each one in the Faber series is interesting and important, covering ceramics from all over the world and from the earliest times to the time of publication. It is well worth trying to locate as many of them as possible, particularly the ones on Chinese celadon, Korean pottery, Japanese pottery, and medieval ceramics – especially *Mediaeval English Pottery* by Bernard Rackham.

The Milner-White Collection was one of the first significant collections of contemporary ceramics in Britain. Eric Milner-White was the Dean of York Minster, and his very important collection was assembled using what Sarah Riddick describes as 'an intuitive and highly discriminating aesthetic sense'. The collection includes the *Leaping Salmon* pot by Bernard Leach, probably the most photographed and celebrated studio pot in the world.

To gain a greater understanding of the philosophy which drove potters like Hamada and Bernard Leach, one should read *The Unknown Craftsman* by Soetsu Yanagi. If you enjoy and appreciate the work of Leach and Hamada, *Hamada: Potter,* written by Bernard Leach himself, is essential, as are most of Leach's own books, including *The Potter's Challenge* and *A Potter in Japan*. For a critical appraisal of Bernard Leach, read Edmund de Waal's book *Bernard Leach*.

When it comes to investigating and collecting source items, in addition to Yanagi's *Unknown Craftsman* it is certainly worth reading *Cycladic Art* by Lesley J. Fitton. There are many books on Korean ceramics, but the one I would particularly recommend is a more general book called *Korean Arts of the Eighteenth Century*, edited by Hongnam Kim.

Bernard Leach's *Leaping Salmon Vase*, ht: 33 cm (13 in). Arguably this is the most famous and coveted studio pot in the world. It is housed in the York City Art Collection. *Photo courtesy of York City Art Gallery and Museum.*

The best guide to galleries is called *Craft Galleries Guide*, compiled and edited by Caroline Mornement, while new for 2007 is the *Galleries of Australia and New Zealand*, compiled and edited by Caroline and Adam Mornement. Both are published by BCF Books, whose website is www.bcfbooks.co.uk. Finally, there are magazines that will help you to find out more about the makers of ceramics, their thoughts and the techniques they use. Amongst the best of these are *Ceramics: Art and Perception*, *Ceramics Monthly* and *Ceramic Review*.

Displaying Your Collection

As soon as you start to build up a collection, you have the problem of how to display it to do it justice. May I suggest that 'less is more'! Too many pots in one area detract from the quality of the pieces and make them far more difficult to be properly viewed. To be fully appreciated, a three-dimensional object needs space, so give a pot a space of its own if you can.

Of course, it is one thing to say this and quite another to do it. If, like me and, to a much greater extent, Bill Ismay, you very quickly become addicted to pots, you will fast run out of space! I am sure that the true pot collector would say that to be appreciated completely a pot needs to be handled, and thus it can best be appreciated by being removed from its place to be contemplated by both hand and eye.

Some people like to place their pots on stands; others think they look better placed straight onto a surface.

If you display your ceramics on shelves, try to ensure that they have a light surface behind them to reflect whatever natural light there is. Many galleries display pots on white plinths, and it is difficult to improve on this as a surface for showing form and decoration clearly.

If natural light is poor, it is a good idea to consider some ceiling-mounted spotlights. Spotlights on a track or a stem of four can be made to shine in several directions, and can therefore be used to good effect on shelving on both sides of a relatively small room.

As shown earlier in the book, tea bowls – both yunomi and chawan – look good on racks built for CDs or DVDs.

All antiques experts will advise you against using expanding plate holders to display plates on a wall. These put extreme pressure on the rims of plates and can result in all kinds of damage.

Above: Detail from painting, in author's own collection.

Opposite: Interior of Phil Rogers' gallery in Wales, showing a number of good display techniques. including use of glass cabinets, shelving and stands. The importance of effective lighting is also shown. *Photo courtesy of the artist.*

Bibliography

Akaboshi, Goro and Nakamaru, Heiichiro, *Five Centuries of Korean Ceramics: Pottery and Porcelain of the Yi Dynasty* (Weatherhill/Tankosha, 1975).

Birks, Tony, *The Art of the Modern Potter* (Country Life, 1967).

Birks, Tony, *Hans Coper* (Marston House, 1983).

Birks, Tony, *Lucie Rie* (London: A & C Black, 1987).

Birks, Tony & Wingfield Digby, Cornelia, *Bernard Leach, Hamada and Their Circle* (Oxford: Phaidon/ Christie's, 1990).

Cardew, Michael, *Pioneer Pottery* (Longman, 1969).

Carter, Pat, *A Dictionary of British Studio Potters* (Scholer Press, 1990).

Casson, Mick, *Pottery in Britain Today* (Alec Tiranti, 1967).

Coatts, Margot, *Lucie Rie & Hans Coper: Potters in Parallel* (Herbert Press/Barbican Art Gallery, 1997).

Cooper, Emmanuel, *Bernard Leach: Life & Work* (Yale University Press, 2003).

Cooper, Emmanuel, *Janet Leach: A Potter's Life* (Ceramic Review, 2006).

Cooper, Emmanuel (ed.), *The Ceramics Book* (Ceramic Review Publishing, London, 2006).

Cooper, Ronald G., *The Modern Potter* (John Tiranti, 1947).

De Waal, Edmund, *Bernard Leach* (St Ives artists series) (Tate Gallery Publishing, 1997).

Dodd, Mike, *An Autobiography of Sorts* (Canterton Books, 2004).

Dormer, Peter, *The New Ceramics* (rev. edn) (Thames and Hudson, 1995).

Fitton, Lesley J., *Cycladic Art* (British Museum Press, London, 1999).

Fournier, Robert & Sheila, *A Guide to Public Collections of Studio Pottery in the British Isles* (Ceramic Review Publishing, 1994).

Fujioka Ryoichi, *Arts of Japan 3: Tea ceremony utensils* (Weatherhill, 1973).

Gompertz, Godfrey St. G. M., *Korean Pottery & Porcelain of the Yi Period*, (Faber & Faber, London, 1940).

Gregory, Ian, *Sculptural Ceramics* (A&C Black, 1992).

Harrod, Tanya, *Alison Britton: Ceramics in Studio* (Bellew, 1990).

Haslam, Malcolm, *William Staite Murray* (Crafts Council/Cleveland, 1984).

Hayashiya, Seizo, *Chanoyu: Japanese Tea Ceremony* (Japan Society, 1979).

Hill, Tony, 'W.A. Ismay: Ever the Potter's Friend' (unpublished speech from the memorial lecture for W.A. (Bill) Ismay at York City Art Gallery, 8th Sept 2001).

Hogben, Carol (ed.), *The Art Of Bernard Leach* (Faber & Faber/Watson-Guptill Publications (USA), 1978.

Houston John, *The Abstract Vessel* (Bellew, 1991).

Jackson, Lesley & Malone, Kate, *Kate Malone: A Book of Pots* (London: A&C Black, 2003).

Kim, Hongnam (ed.), *Korean Arts of the Eighteenth Century: Splendor & Simplicity* (New York: The Asia Society Galleries, 1993).

Leach, Bernard, *A Potter's Book,* (Faber & Faber, 1940).

Leach, Bernard, *A Potter's Portfolio* (Lund Humphries, 1951).

Leach, Bernard, *A Potter in Japan* (Faber & Faber, 1960).

Leach, Bernard, *Bernard Leach: A Potter's Work* (Evelyn, Adams & Mackay, 1967).

Leach, Bernard, *Hamada, Potter* (Kodansha, 1975).

Leach, Bernard, *The Potter's Challenge* (Souvenir Press, 1976).

Leach, Bernard, *Beyond East and West* (Faber & Faber, 1978).

Lucie-Smith, Edward, *Elizabeth Fritsch: Vessels from Another World* (Bellew, 1993).

Mansfield, Janet, *Salt-Glaze Ceramics: An International Perspective* (A&C Black, 1992).

Minogue, Coll & Sanderson, Robert, *Wood-fired Ceramics: Contemporary Practices* (A&C Black, London/University of Pennsylvania Press, Philadelphia, 2000).

Mornement, Caroline, *Craft Galleries Guide* (9th edition), (BCF Books, Yeovil, 2008).

Mornement, Caroline, *Galleries of Australia and New Zealand* (BCF Books, Yeovil, 2008).

Munsterberg, Hugo, *The Ceramic Art of Japan: A Handbook for Collectors* (Charles E. Tuttle Company, 1964).

Okakura, Kazuo, *The Book of Tea* (Charles E. Tuttle Company, 1956).

Peterson, Susan, *Shoji Hamada: A Potter's Way and Work* (Kodansha, 1974).

Rackham, Bernard, *Medieval Pottery,* (Faber & Faber, London, 1948).

Rawson, Philip, *Ceramics* (OUP, 1971).

Rice, Paul, *British Studio Ceramics* (Crowood Press, 2002).

Rice, Paul, *Sam Haile: Potter and Painter* (Bellew, 1993).

Riddick, Sarah, *Pioneer Studio Pottery: The Milner-White Collection* (Lund Humphries, 1990).

Rogers, Phil, *Ash Glazes* (2nd edn) (A&C Black, 2003).

Rogers, Phil, *Salt Glazing* (A&C Black, 2002).

Rogers, Phil, *Throwing Pots* (A&C Black, 1995).

Rose, Muriel, *Artist Potters in England* (rev. edn) (Faber & Faber, 1970).

Sanders, Herbert H., *The World of Japanese Ceramics* (Kodansha International, 1967).

Sen, Soshitsu, *Chado: The Japanese Way of Tea* (Weatherhill, 1979).

Tchalenko, Janice & Watson, Oliver, *Janice Tchalenko: Ceramics in Studio* (Bellew, 1992).

Watson, Oliver, *Studio Pottery* (V&A/Phaidon, 1990).

Whybrow, Marion, *Leach Pottery St Ives: The Legacy of Bernard Leach* (Beach Books, 2006).

Wingfield Digby, George, *The Work of the Modern Potter in England* (John Murray, 1952).

Wood, Nigel, *Chinese Glazes* (A&C Black/University Pennsylvania Press, 1999).

Yates-Owen, Eric & Fournier, Robert, *British Studio Potters' Marks* (rev. edn) (A&C Black, 2005).

Yanagi, Soetsu, *The Unknown Craftsman, A Japanese Insight into Beauty* (Kodansha International Ltd, 1978).

Glossary

Anglo-Oriental Style of potting whose origins derive from Sung Dynasty Chinese and English medieval pots. Bernard Leach and his companions are credited with creating it.

Ash glaze Glaze in which ash is used as a flux with ground stone.

Blister Raised area or a crater that may be the result of bubbles of gas escaping from the pot during firing. If they do not settle as the firing continues, blisters result.

Celadon Oriental glaze, normally used over porcelain or stoneware in reduction firing, and usually pale blue or green in colour.

Choson or Yi Dynasty Dynasty in Korea (1392–1910), whose pots strongly influenced studio potters.

Chun Pale-blue opalescent glaze.

Crawling Fault whereby glaze bunches in certain areas, leaving others bare. It can be used for a deliberate glaze effect.

Dunting Crack in pottery where a draft of cold air has struck the pot, causing localized contraction during the firing or cooling process.

Earthenware Usually pottery made from red clay fired to below 1200°C/2192°F, quite often highly decorated with yellow, green or brown slip. Because it can only be fired to a relatively low temperature, it is usually porous.

Earthstone A proprietary brand of clay used for hand-building. It is extremely warp-resistant and fires very white.

Firing Process of changing clay into pottery, occurring at over 600°C/1112°F.

Foot-ring A pedestal resulting from the potter inverting the pot and cutting away some clay from the thick area at the bottom of it, which is left after throwing.

Fluting Decoration created by cutting regular grooves into the clay surface.

Glaze Glass surface on clay, making a pot stronger, non-porous and attractive.

Hakeme Korean decorative technique created by drawing a brush through white slip.

Nuka White glaze made from rice-husk ash.

Onggi Traditional Korean pottery made from long 'snakes' of clay attached on the wheel and beaten into shape with paddle and anvil. Used for food.

Press-moulded Forms created by pressing clay into moulds and joining the parts.

Porcelain Kaolin-based pottery that is white, high-fired and translucent. It is often decorated with blue or green celadon glaze, or a white glaze.

Raku Low-temperature pottery created by fast-firing, and often used for chawan.

Reduction Firing process which starves the atmosphere in the kiln of oxygen, resulting in changes to glazes.

Salt glaze Glaze achieved, usually on stoneware, by throwing salt into the kiln at 1200°C/2192°F or above. Salt vapour combines with silica in the

clay to produce a glaze. This can produce a stunning effect, often in orange, blue, brown or green, depending on the slip used.

Shino Originating in Japan, a type of viscous glaze often applied over painted iron oxide.

Slipware Earthenware ceramics with the decoration applied with slips (runny clay) under a glaze.

Standard ware Pots produced to a pattern for everyday use.

Stoneware Pottery fired to over 1200°C/2192°F, making it impermeable and strong.

Sung Dynasty Chinese dynasty (960–1279AD) whose uncomplicated pots influenced studio potters.

T-Material A very refractory white clay with a high content of molochite, which is excellent for handbuilding and can be added to raku bodies.

Tamba An important centre in Japan for the production of simple everyday items such as storage jars and mixing mortars. Its unglazed ware has a characteristic reddish brown colour.

Tea ceremony Formal gathering where tea is drunk from a single bowl to enlighten the soul. Many studio pottery ceramics relate to it.

Tenmoku Oriental glaze which usually varies from reddish-brown to black.

Wax resist Decoration applied with wax so that glaze or slip will not stick to that part of the surface.

Wood firing Firing that uses wood as the fuel, allowing the ash to create a glaze.

Yohen A Japanese term that describes the effects of wood-firing on a pot. The effects are varied and include all that can be changed by fire in the kiln.

Useful Websites

Studio Pottery www.studiopottery.co.uk/index-f.html
(Comprehensive lists of potters, galleries and links.)

Mike Sanderson www.ceramike.com/index.htm

David Binch www.oakwoodceramics.co.uk/index.htm

Robert Yellin www.e-yakimono.net

Milner-White & Bill Ismay's collection www.yorkshiremuseum.org.uk

Dick and Jo Chadwick www.theceramicstudio.co.uk

University of Wales, Aberystwyth www.aber.ac.uk/ceramics/index.htm

The Craft Potters' Association www.cpaceramics.com/cpa.html

Ceramic Review www.ceramicreview.com

Hannah Peschar Sculpture Garden in Surrey
www.hannahpescharsculpture.com

The Sainsbury Centre for Visual Arts, University of East Anglia, Norwich
www.scva.org.uk

Museums and Galleries

Surprisingly perhaps, there are a number of high-quality museum collections of contemporary ceramics. Britain's largest one is at the Victoria and Albert Museum in London, but there are also good collections in Aberystwyth, Southampton, Portsmouth, Liverpool, Aylesbury, Bristol, Farnham, York, Oxford's Ashmolean and many other provincial museums. Unfortunately, many of the pots are in the reserve collections, so you need to arrange in advance to see them. *A Guide to Public Collections of Studio Pottery in the British Isles* by Robert and Sheila Fournier covers most of the collections and, failing this, the internet is a reliable source of information. Many excellent pots can also be seen and, more importantly, handled at large auction houses.

Gallery websites

Alpha House Gallery, Sherbourne, Dorset. www.alpha-house.co.uk
Angela Mellor Gallery, Ely, Cambs. www.angelamellorgallery.com
Anthony Shaw Collection, London www.anthonyshawcollection.org/welcome.htm
Barrett Marsden Gallery, London www.bmgallery.co.uk
Beddington Fine Art, France www.beddingtonfineart.com/index-2.html
Bircham Gallery, Holt, Norfolk www.birchamgallery.co.uk
Bowie and Hulbert, Hay-on-Wye www.hayclay.co.uk
Browse and Darby, London www.browseanddarby.co.uk
Cecilia Colman Gallery, London www.ceciliacolmangallery.com
Ceramour Gallery, Boulogne, France www.ceramour.com/index.php
Contemporary Ceramics, CPA Shop, London www.cpaceramics.com
Galerie Besson, London www.galeriebesson.co.uk
Gallery at Bevere, Worcester www.beverevivis.com
Goldmark Gallery, Uppingham, Rutland www.modernpots.com
Harlequin Gallery, South London www.studio-pots.com
Joanna Bird Pottery, London www.joannabirdpottery.com
Old Chapel Gallery, Pembridge, nr Leominster www.oldchapelgallery.co.uk
Primavera, King's Parade, Cambridge www.primaverauk.com
Red Door Gallery, South London www.reddoorgallery.co.uk
The Hart Gallery, Nottingham and London www.hartgallery.co.uk
The Scottish Gallery, Edinburgh, Scotland www.scottish-gallery.co.uk
The Stour Gallery, Shipston-on-Stour, Warwickshire www.thestourgallery.co.uk
Where I Fell in Love Gallery, Warwickshire www.whereifellinlovegallery.com
Zimmer Stewart Gallery, Arundel, Sussex www.zimmerstewart.co.uk

An excellent gallery without website at the time of writing:
Paul Rice Gallery, 3 Tring Avenue, Ealing, London, W5 3QA.
 Tel/Fax: 0044 (0)2089 924186 email: paulricegallery@hotmail.com

Index